Dyke The Halls

Lesbian Erotic Christmas Tales

edited by
Linda Alvarez

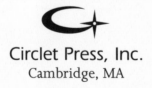

Circlet Press, Inc.
Cambridge, MA

Dyke The Halls

Printed In Canada
ISBN 1-885865-46-5

First Printing October 2003

Circlet Press is distributed in the USA by SCB Distributors.
Circlet Press is distributed in the UK and Europe by Turnaround Ltd.;
Circlet Press is distributed in Australia by Bulldog Books.

For a catalog, information about our other imprints, review copies, and other information, please write to:
Circlet Press, Inc.
1770 Massachusetts Avenue #278
Cambridge, MA 02140
circlet-info@circlet.com
www.circlet.com

Contents

Introduction

Linda Alvarez

One of the first things we often think of when we think of Christmas is Family. After all, Family is at the heart of what the holiday is celebrating: a birth. But also, for so many of us, our childhood memories of the holiday tend to be so vivid and strong.

Also, for so many of us, our adult realities of the holidays are not as idyllic, and not just because we know that No, Virginia, there is no Santa Claus. In some cases, our families have rejected us for being who we are. For many of us, our religion denounces us for loving as we do. And in general, Christmas has become such a frenzy of consumer culture and con-

sumption that it's enough to give one a sort of moral indigestion (or a physical one, if you're trying to second guess who will give you presents and if you have to give them presents in return and what they'll want and...)

At the same time, sometimes we are able to find the magic of Christmas again, even as adults, and it's those festive Christmases that this book tries to celebrate. And in celebrating Queer Christmases, this book is meant to be a bit irreverent, frolicsome... just right for all the girls on Santa's "naughty" list.

While collecting the stories for this book, two themes appeared again and again:

It's obvious that we lesbians have a fixation with dressing up as Santa, perhaps something to do with subverting that oh-so-patriarchal icon of the Holiday. In Latino cultures we have Los Reyes, the three kings of orient, who come delivering presents instead of Mr. Claus. And even though we don't have camels in the United States for them to come riding in on to deliver their largesse, this story always made a lot more sense to me because historically the three magi did bring presents to the baby Christ (to say nothing of the flying reindeer!).

We're also terrorized by how our parents might

(or do) treat us when we bring our girlfriends home with us for the holidays. So many stories of dykes using sex to release the tension of family stress and heal the wounds... Of finding comfort in the embrace of the families we make by choice when our blood families turn their backs on us.

I could only include a few of each of these types of stories in this collection in my attempt to achieve a thematic balance and explore other perhaps less-charted regions of the Holiday Season.

Have candy canes fallen out of favor in these days of health-consciousness? Or perhaps they're simply too obvious. Still, I was surprised that none of the writers really went there... Although they came up with some delightful surprises instead, such as Andrea Dale's really hot tale, "Frozen."

Another surprise: our Jewish sisters seem to be fascinated by Christmas, at least judging by the number of stories submitted by Jewish writers.

I hope this book is a celebration of everything lesbian during the Holiday Season. May it bring some light and joy into your life, may it serve as a distraction from the hyper-consumerism and stress the Holidays bring, from anxieties about family, both those by blood and those by choice.

And maybe it'll inspire you to try something new to celebrate the holidays and make a lover shout her joy to the world.

Linda Alvarez
December 2003

When the Giving Got Good

M. Christian

"Hope you like it," Ophelia said, sitting crossed-legged on their scratchy bulls-eye rug, a wide, sweet smile on her face. She was good at a lot of things—finding a parking space on even the most insanely crowded street, making a rum cake that would make the Pope cry, giggling at cartoons—but she wasn't that good at hiding her excitement; not when the perfect spot opened up right in front of her, not when she made a rum cake that actually made her cry, not on Saturday morning just before the PowerPuff Girls, and definitely not on Christmas morning.

"Well, I hope you like mine, too" Henri said, perched on the edge of her favorite chair, a simple blue rocker, fingers knitted together in elegant contemplation. She was good at a lot of things—singing an aria from La Boheme, expounding on Aboriginal culture, debugging Windows—but even she wasn't that good at hiding excitement. Not when she hit that note just right, not when she suddenly understood what the Dreamtime was really about, nor when she got the damned thing to boot, and definitely not on Christmas morning.

"I know I will," Ophelia said, her tones musical, a wind chime caught in a warm, breezy wind. In photos, she was the beaming one, the bright and shinning one. Hair the color of polished gold, cut into a precious bowl, Ophelia was a sprite, a faery, a nymph: marzipan and spun sugar. Something that should be dancing on the top of the tree.

"And I know that whatever you give me will be wonderful," said Henri, her voice low and rumbling, thunder and deep ocean waves. In photos, she was the dark one, a great mahogany Buddha. Hair kinked and curled, only a little blacker than her gleaming obsidian skin, Henri was strength, determination, caution and concentration. She was a mighty oak, a

stately sequoia.

In the nearby kitchen, stuck to the white, pebbled metal of the fridge by a magnet disguised as sashimi and surrounded by similarly magnetic letters spelling out elegant haiku (Henri) and girlish dirty words (Ophelia) was a single photograph: the sprite with thin white arms around the black Buddha. Despite their differences, there was a commonality about them. In spite of their different ways of doing it (smiling) and being it (happy), they were doing it obviously with each other, together.

There was just one picture on the fridge, a photograph of the two of them. Just one. And it wasn't that old: Less than a year, no more than a few months.

"Our first Christmas together. I'm so excited!" Ophelia said, reaching for her clowns and balloons coffee mug for an experimental sip of still-too-hot-to-really-drink cocoa.

"I can tell, sweetness," Henri said, taking a bite of rum cake from the plate precariously balanced on the arm of her rocker. "And so am I."

"I can't wait for you to see what I got you. I'm sure you're going to love it."

"I'm sure I will. I just hope you like mine."

"Oh, I know it's going to be fabu," Ophelia gig-

gled, stretching out to grab a big box wrapped with gold and silver stars, curly ribbons, and a miniature snow-frosted tree, from in front of their cold, non-working fireplace. "'Cause it'll come from you!"

"Oh, you say that," Henri said, taking another bike of cake and moving the plate down to her feet, "but I don't want to disappoint you."

"You won't, silly!" Ophelia slid her big box over to her lover's sandaled feet, touching unpainted toes to wrapping paper. "Open! Open! Open!"

"Not yet, sweetness," purred Henri, bending down to retrieve a small brown box from where it had been carefully hidden under her chair. "This is for you."

"Oooooh," cooed Ophelia, accepting it with reverence, but then shaking it once, good and hard, next to her tiny ears, listening for any incriminating sounds. "I can't wait!"

Henri laughed, a base drum in the small room, the sound rolling off the walls. "It's a little something, but I hope it shows how much I care for you."

The sprite looked sad with joy for a moment, but the face wouldn't hold against her animated features. When it collapsed with a wide grin she bent down, picked up the big box and presented it to Henri.

"Ditto! Let's open them together."

"Okay, that'll be fun." Henri's voice was softer than usual, hushed by nerves. "I just hope you didn't spend that much You know we don't have a lot of money."

"I know, I know — but it's Christmas, and Christmas is about giving and getting stuff. Can't have Christmas without giving and getting, right?"

"You're right. You're absolutely right, sweetness." Now her great voice was a low squeak. She surreptitiously wiped the back of her right hand under her eyes, hoping that the other girl didn't notice.

"Besides, silly, it didn't cost me anything! Not that you're not worth a lot, I mean."

Ophelia laughed, a bit deeper, a bit more assured. "I know what you mean. That's what I did with your gift as well. But you're priceless."

"Oh, silly!" Ophelia continued to rattle the box, trying to decipher the contents. "I was in the Community Exchange just the other day when I saw it. Your present, I mean. It leaped right out at me, saying 'I'm just the right thing for Henri! Take me! Take me!' You know me, I can never say no to just the right thing." She stopped rattling and scooted over to rest her head against the big woman's thigh.

Henri stroked her blond hair. "You are a precious girl, sweetness," she said, voice cracking yet again. She juggled her own present. "It is awfully heavy. I wonder what it could be?"

"Open! Open! Open!" chirped Ophelia, lifting her head and smiling. "I can't wait."

"Do yours, too. Come on, we'll open it together. Funny that you mention the Exchange, because that's where I got yours. Mary even said that it was the perfect present for you."

"That's so funny, Mary said the same about yours as well. She is such a sweetheart, isn't she?"

"One of the best things in this world, I think. Right up there with you, sweetness." Tape popped, stretched until it broke over her finger. A bit of cardboard under the wrapping was revealed.

"Oh, you!" Ophelia giggled, while she worked the top off her box.

Paper rustled, some tore, cotton was lifted aside. Dark eyes glanced over at blue, blue back at dark, watching each other watching each other, hoping for flashes of excitement and happiness, praying against disappointment.

Ophelia first, Henri handicapped by colorful wrapping paper. She held it up in front of her eyes:

tiny, silver, and elegant, the soft music it made in their tiny room was clear and sharp. "It's a bell!" giggled Ophelia, chiming it gently with a rose and gold colored nail. "It's beautiful!"

"It's for your nipple ring," Henri said, bending down to be closer. "So you can wear it always, and so every time it rings you can remember me."

The sprite sniffled. "Oh, oh, oh," she said, unable to continue. "It's really lovely. Really, it's just that, well, I don't have my ring anymore, Henri. I'm so sorry! I traded it for … for what I got you."

Henri was dumb. She looked at the tiny silver chime, listened to the single clear note it still gently played between Ophelia's fingers. "Oh, sweetness, I didn't know."

"It's okay. It's okay, it really is. I'll keep it in my pocket. I'll put it on a string around my neck. It's wonderful, so special," she sniffled, loud and long, then looked embarrassed. "I'm sorry," she said, not really understanding why she said it. "Now you open yours. Open it! I'm sure you'll love it."

"Okay," the numb Henri said. Papers peeled completely away, revealing a box. The box was opened, revealing newspapers. Newspapers were pulled out showing something dark and wooden.

Henri held it up. "It's, it's —" she started to say, but didn't finish.

"It's a rack! A whip rack! I was in the Community Exchange and just had to have it. Won't it be perfect for your flogger? You know, your favorite Jay Marsten toy? Won't it look wonderful?"

"My flogger? Oh, dear … sweetness …."

"Don't you like it? I thought it was just right for you. Isn't it?"

"I think it wonderful. Really, it's perfect. It's just that, well, sweetness, I don't have the flogger anymore. I traded it in … for your bell."

Ophelia looked at Henri. Henri did the same back at Ophelia. The air grew clear, fragile, like it was going to shatter with tension.

Then Henri bellowed with delight, a great explosion of happiness, and dropped down off her chair to grab the little blond sprite. Then Ophelia shrieked with joy, and rose to wrap arms around the big black Buddha while they both laughed and cried, cried and laughed, until they both fell over into a black and white, black and white tumble on the rug.

\#

"My sweetness," Henri said, between long, soulful and quick, innocent kisses, her big arms wrapped around thin, little Ophelia.

"No," Ophelia, dreamy grin on her face, "you're the sweet one. Sweet as anything. As sugar," a kiss on Henri's nose, "as honey," another kiss, same nose, "as frosting on a big piece of cake," another kiss—much longer, much deeper, lips to lips. After a long, slow time, it broke, and Ophelia finished her list with "as love."

Henri smiled, reaching down to lift the thin girl's T-shirt, exposing a buttery expanse of soft tummy. "Au contraire," she said, lifting her head just long enough to playfully wag a finger, "you are the one who is sugar, honey, and frosting. All the good and precious stuff in this world is right here." Back to her rise of belly, a kiss to the silken skin.

"Oh," Ophelia said, voice tender and slightly lost.

"— and right here, of course." Ophelia had started the day in her T-shirt, still on, though pushed up, and comfy, slightly threadbare sweat pants. But not for long. Dark fingers slipped between skin and pants, Henri gently tugged, persistently tugged, and then, when they were down to her ankles, off—tossed into a far corner without a further thought.

"Oh," Ophelia, said voice even more tender, even more lost.

Hands on her thighs, with very little insistence, Henry parted her legs. Eyes wide with glee, and more than a little wonder, she stopped to look, to simply look. After a time she said, repeating but meaning more: "All that's precious and good in the world. Well, my world, at any rate. I could just eat you up."

Another kiss, different set of lips: Henri to Ophelia. Fingers gently stroking down, touching the smaller girl's outer lips, then holding them, pulling just enough to part. Again, a look, a watch, an admiration, before that kiss. After the kiss, lips to clit this time, Henri to Ophelia, another kiss. But then it was more than a kiss, or just a different form of a kiss: lips and tongue, stroking, flicking, washing, following the lifts and tucks, the silken contours of her. In response, Ophelia cooed and purred, a great blond kitty, and spread her legs a bit more.

No time. Nothing in the world but Henry, kneeling down, lips and tongue, then fingers, playing her lover, playing with her lover. It really wasn't a goal, per se, but it happened anyway: Ophelia's breathing quickened, her thighs tensed, her fingers gripped the rug in itch-filled fists, and then it came out, hissed

and screamed out of her.

"Sweet, deliciously sweet—" cooed Henri, running her fingers up and down Ophelia's thighs, tactile applause. "I could just eat you up, nibble on you all day."

"Whew!" the thin blond girl said, springing up—elbows on the rug, propping herself up. A thin strand of gold hair lazily dripped down her forehead. "I do exclaim, I do: whew!"

Henri didn't say anything. She just traced slow, lazy circles on Ophelia's tummy and smiled.

"— and as for who's the tasty one!" Quick, giggling like a maniac, hands suddenly on Henri's wide shoulders, pushing, toppling the bigger woman back. Tangled, this time it was Ophelia on top, Ophelia's hands that were tugging at clothing, revealing the other woman's mountainous, black breasts and even darker, already hardening nipples.

"Oh, no, oh, no, oh, no, oh, no, oh, no, oh, no, oh, no, oh, no" Henri said, eyes wide, mouth open. "You're not going to —"

"I most certainly am," Ophelia said, her words slurred, her teeth cleanly locked around Henri's nipple. "Asfolutery, ah am."

"Oh, no, oh, no, oh, no, oh, no," Henri said, her

deep voice breaking, straining as the spill of denial flowed from her mouth.

"Weady?" the other girl said, delight and mischief winking in her pale blue eyes.

"Oh, no —" Henri started, but didn't finish. The next words—probably "Oh, no"—were cut off, washed away by a sharp, long hiss as Ophelia's teeth carefully, methodically, bit down onto her swollen nipple.

The squeeze was consummate, the control expert. Pearly whites like exact tools, perfect clamps. Slowly, glacially, Ophelia bit down just a bit more, anywhere else on the body unnoticeable—on Henri's fat, erect nipple, it was like a steel trap teasing at one of her most sensitive points.

Again, a bit more force, again the low hiss like steam that whistled out from between Henri's lips, but this time there was something more: a flick, a touch of warm wetness as Ophelia's tongue touched, then grazed, then stroked at the very tip.

The teeth went on, squeezing down harder and harder, the tongue went on, licking, adding something subtle and sweet to the ferocious bite. Sometimes, Henri would come this way, just from Ophelia's precise nibbles to her breasts and nipples.

But sometimes she needed, or just wanted, something more.

Still leaning back, she freed one arm, turning herself so she wouldn't lose balance, and grabbed hold of Ophelia's left arm. At the touch, the other woman allowed herself to be led, hand grazing the front of Henri's jeans. "Rub me … please," Henri managed to hiss out, the fear of having to move with Ophelia's teeth still locked around her nipple almost pushing her over the edge.

Ophelia smiled, never once releasing her grip, and with that guided arm, she undid Henri's belt, unbuttoned her fly, and snaked her hand down between her thighs.

Warm, at first, then hot. Humid, at first, then steamy—then wet as Ophelia's fingers deftly slipped between her lover's great thighs. There, down among slippery lips, she found what she was looking for, what both of them were hoping for: a hard kernel, a very firm clit.

Lips and teeth tight and relentless, tongue magically adding to it all, Ophelia rubbed Henri's clit, building it all up, pushing her lover up higher and higher—until there was nowhere else to go.

Henri's version was a bellow, a roar, a scream that

tensed and released through the whole body. Even one of her legs was sucked into the wonderful release: it kicked and jerked in perfect tune with her heavy breaths, beat of moans and sighs.

She collapsed, falling back onto the rug, arms out at her sides, legs recklessly apart. On top, snuggling up to her breasts, curling around her thighs, Ophelia curled and folded herself so that as much of her as possible was touching the other woman, and that way they both faded, drifted off, and slept, dreaming of sugar, sweetness, heat, steam, and, of course, each other.

\#

Sometime later, one woke—with the other following right after. Grinning as they stumbled, they got drinks, went to the bathroom, but mostly just stood in the middle of their tiny apartment and kissed: lips to lips, back to white, big to small, love and love.

Few minutes later, after some relief and sips of water, they decided to take a little walk, to enjoy something amazing and absolutely free: the sights and sounds of their nice neighborhood, their lovely

city.

When they opened the door they saw the box. Wrapped in pretty, and somewhat familiar, paper: gold stars, pale blue. Very pretty.

Puzzling, they took it inside, tore and peeled back the paper, opened the box. Inside were two simple, but very special, things: a lovely leather flogger, and a tiny silver ring—just perfect for a nipple.

There was also a card. Merry Christmas, my lovely friends. I hope you like what I gave you. Never forget that presents are just things, and love, as well as who you love, is the most special gift anyone can give and get in this world. The card was from the Community Exchange, and the signature said Love, Mary.

Salomé

Zonna

'Twas the night before Christmas and all through the house, not a creature was stirring 'cept my heart 'neath my blouse... It beat to a steady rhythm: Lap dance, lap dance, lap dance, lap dance... Visions of cheap porno movies flickered through my sex-starved mind, even though I imagined that if Diana were to actually give me a lap dance, it probably wouldn't be anything like that. Or would it? A thrill shot through me as I realized I had no idea. Not a clue.

Diana was, hands down, the most interesting person I had ever come across. Right from the start it

seemed we were two parallel lines that had somehow found a way to meet. Part Thelma and Louise, part Lucy and Ethel, we brought out the best and the most adventurous aspects in each other. It was an unspoken, ongoing competition, and I loved it. Diana was like those Russian nesting dolls—a series of gifts hidden inside one another. Each time I opened one, I found another beckoning to me. Try me. Look at this. Woohoo! I never could resist a good mystery. And now this intriguing woman had promised me a lap dance as my special Christmas present! The biggest surprise I'd gotten her was a book of hiney photos. I was in danger of being seriously outclassed.

I hadn't believed her at first. We liked to tease each other into a frenzy, and I figured this was just a titillating image she wanted to plant in my mind. And that it was! I had about a thousand dreams, one more erotic than the next, where she would dance for me like a modern day Salome. They sure did keep me warm through a number of cold winter nights. But that's all they were, just dreams. And everyone knows dreams don't come true. She kept insisting she wasn't kidding, though, and I began to wonder if I could possibly be that lucky. Reality check: we were friends, not lovers. Oh, I was hopelessly in love with her, and

we both knew it, but it was quite one-sided. That particular mystery had been solved a while ago.

So when Christmas Eve rolled around and Diana showed up waving a cassette tape with the promised songs on it, I was both surprised and delighted. We enjoyed our day together, saving the dance for last. We swapped presents over lunch at our favorite diner, where we both drank way too many cocktails. We exchanged some sensible presents in addition to the more outrageous ones we'd planned: dvd's, cd's; clothes. She was quite happy with her photo book. We glanced at it between courses, arguing over which were the best depicted derrieres and hiding it from the waitress who seemed to be dying to know what it was that had us giggling so guiltily.

I was having a nice time – that was a guarantee whenever I was with Diana – but I couldn't help feeling restless. I kept sneaking glances at her every few minutes, as I munched away at my Greek salad, wondering just what she had planned. She'd insisted on keeping it all hush hush, driving me nuts with anticipation. I nibbled some lettuce and stared at her breasts, right there across the table from me. She was wearing a red sweater with white snowflakes, and her tits were like snow covered mountains. Oh, how I

would've loved to let my tongue careen down those sexy slopes. I wondered if, like a real lap dance, she would take off any of her clothes. I thought she might possibly strip down to her underwear or flash her boobs at me, or something—but I wasn't sure. I popped an olive into my mouth and imagined her nipples, hard and firm. I chewed and stared and dreamed. What did she have planned? I didn't contribute much to the conversation, as my mind was already back home waiting to discover what this tightly wrapped gift would reveal. Each time she caught my eye she winked or smiled, making me blush as I realized how easy it must be for her to see through the paper thin tissue that hid my desire.

We negotiated the slippery streets and returned to my place. I lit a fire to chase the chill away. The Christmas tree twinkled in the corner, as the fire was reflected in each strand of tinsel. We listened to some music as we thumbed through the glossy globes again. We talked. We had a glass of wine. We talked some more. We laughed a lot, though I'm not sure if either of us actually said anything funny. The wine was making me deliciously dizzy. I could see that Diana was in a similar state. Still, neither of us mentioned the dance.

Finally, the afternoon was winding down. I looked at her and she looked at me. The air was thick with expectation.

"Well," I said, smiling what I hoped was a mischievous smile and not a desperate one, "looks like there's only one gift left."

Diana was suddenly uncharacteristically nervous and shy. "I don't think I can do it," she confessed.

I was disappointed, but not really. Just the fact that she had considered doing such a wild thing was sweet. I would never want her to go through with it if she was uncomfortable, though, and I told her so. "That's OK," I said, giving her a hug. "You don't have to do anything you don't want to do."

"But I've been practicing since Thanksgiving!" She seemed even more disillusioned than I was.

"Don't worry about it. I had a great day just being with you. That's enough."

We sat on the sofa feeling a little crowded, as an awkward silence squeezed in between us. I glanced out the window. It had started to snow again. It looked so pretty coming down. I loved the way it perched on all the trees and bushes, outlining everything in white.

"Look," I parted the curtain so Diana could see.

She smiled that crazy smile that always makes me want to melt like a snowman on a heat vent.

Suddenly, she jumped up and placed a chair in the middle of the floor. "Sit," she commanded, her voice firm, though a little shaky around the edges.

"Are you sure?" My heart began to pound with the realization that this might happen after all.

Diana just pointed to the chair and I sat my ass down. Oh boy oh boy oh boy, I thought, as she popped the tape into the cassette player. I would never do anything she didn't want me to, and she knew it, but she insisted on tying my hands behind my back anyway, just to be safe. And that allowed me to want her; to let the desire flow over me without having to worry about keeping it in check.

Diana closed her eyes and her body began to sway to the music. She's such a good dancer. She knows how to move; how to make it all look so effortless. I am hopelessly spastic, self-conscious and stiff. It's almost as if she is a brook, splashing joyfully about, and I am a rock, sitting solid and immobile. Watching her made me wish I could dance with her, though I was happy enough to simply remain where I was and enjoy the view from the best seat in the house.

She opened her eyes after a few measures. When

she met my gaze, I was surprised to see just how excited she was. I smiled. She became emboldened and began to strip to the music. I couldn't believe she was really doing this for me. I could tell she was well rehearsed; it was smooth and perfectly in time. I was getting so turned on, I was thankful for the ropes. I watched in fascination as she slithered out of her clothes, slowly shedding piece after piece. By the time the first song was over, she was completely naked, and I was soaking wet.

Her breathing was a little uneven as she waited for the next song to begin. I wondered if it was from the movement, or if she was getting a rush out of having me watch her? I knew she was a bit of an exhibitionist, and I imagined this might be as thrilling for her as it was for me. Each time our eyes met, there was a spark between us. As it became obvious that she liked knowing I was looking at her, I stared harder. I licked my lips. "You're so fucking hot," I whispered, but I wasn't quite sure if the words came out or not. This is really happening, I thought. If my hands were free I would have pinched myself.

The second song came on and I watched her ease into the rhythm. I delighted in the way her tits shook, enticing me to reach out and grab them. I couldn't,

of course. My mouth watered. Her nipples were hard and they beckoned to me like little, red holly berries. I imagined my tongue washing over them; my lips sucking gently at first, then harder. I tried to send her a telepathic message; willed her to come closer so I could take one in my mouth, but it wasn't in her plan. I watched her hips shimmy and sway. I was mesmerized. Salome herself could not have had a more rapt audience. Diana turned and allowed me to gaze at her sweet ass as it wiggled sensuously. I had been fortunate enough to touch it once, and the memory flooded over me. It was soft and round and sexy, and it was right there in front of me; just out of reach. I began to sweat. You would never guess from looking at me that St. Nick was hitching up the great eight and consulting his road map. You would probably be more apt to think it was the Fourth of July.

The bass pounded and Diana bucked her pelvis in time with it. What a move! She raised her arms over her head, giving me a full view of her breathtaking beauty. This was the best gift I had ever received. She danced and the flames danced with her. I watched quietly, envious of every bead of sweat that wended its way between her breasts.

Just when I thought it couldn't get any better, she

came closer and lowered herself slowly onto my lap. I had to remind myself to keep breathing. I wanted to kiss her, but I knew the rules. She teased me mercilessly. She lifted her tits and rubbed them up against my face. I tried to catch one in my mouth, but she chuckled softly and pulled it away. She leaned in and gave me a quick kiss on the lips; hardly a kiss at all, just the idea of a kiss, really. It went right through me. I struggled to free my hands, but the bonds were too secure. I could feel her breath on my face, the warmth of her body wherever it pressed up against my own; then the loss of heat as she moved away. Her eyes were laughing. She knew exactly what she was doing to me.

She stood again, and I realized the song was nearly over. I wondered what she had planned for her big finale. Knowing Diana, I was sure it would be something unforgettable. And then, my heart nearly stopped as I watched her hand move closer and closer to her cunt. She wouldn't, I thought. I was sure it was my imagination. I blinked my eyes, but there was her hand, still headed toward it's obvious destination. Her finger dipped just inside and I moaned. I knew she heard me, even over the music. Then she offered me a taste, and I sucked greedily at her honey dipped

digit. I was so aroused, I thought I might come without even being touched. I have never wanted anyone so much in my entire life. The combination of the strong feelings I had for her, plus her erotic dancing, plus the fact that it was impossible for me to reach out and take her, all added up to a white hot desire.

Fortunately, she didn't untie me until she was fully clothed. I sat there, willing my heart to slow down to a normal pace. As I did, I noticed the wet spot on my jeans where she had been sitting. That turned me on even more as I realized she had enjoyed the dance as much as I had. I was still shaking when she set me free. I wasn't sure if she noticed, but at that point I didn't care. I had no shame about my feelings for her. They were what they were, even if I wasn't permitted to act on them. And that had been one damned sexy dance!

I gathered her up in my arms and hugged her. "That was so hot… You're the sexiest woman on the planet. I know that was the best gift I'll ever get in my whole life. Thank you."

She smiled and hugged me tighter. "Merry Christmas," she whispered. There were no further words needed between us. We had shared something deeper than any mere language could express.

Every year as the air grows crisp and the stores start playing those sappy holiday songs, I think about her special gift. I'll never forget that day; the way she just let go. She danced with abandon, with joy; with shameless lust. It was primal and sexy and real. I can close my eyes and still see every move and feel that tug inside me. She knew how much I loved her; knew how much I wanted her. And even though that was not in our future, she gave me the next best thing—a glimpse of what it might be like if Salome was mine.

What Santa Gave Me

Susan St. Aubin

You laughed, afterwards. "I can't believe I'm in bed with an elf!"

"What do you expect when you cruise the mall on Christmas Eve?" I asked.

I was the one who sat on Santa's knee when he was between customers because I was the smallest and because I was the only one who was legal. Our Santa was no fool even if he was an old lech who like to fondle my A-cup breasts beneath the glittering spandex top that held them.

"Any more than a handful is a waste," he whispered in my ear.

"Oh, please," I hissed back, bouncing up and down on his knee because that was part of the job, acting like an excited little kid to remind people to keep on buying gifts even late at night after the real kids had gone home to bed.

There were always four or five of us on every shift, mostly high school girls dressed alike in green spandex tights and tops with a bit of midriff showing between the two, green stocking caps trimmed with fake ermine, and ankle boots with curved, pointed toes. Those outfits were a bit drafty, which kept us moving, snuggling with Santa, turning somersaults to entertain the kids waiting in line, and making faces for the small ones, who screamed as their mothers set them down on Santa's knee. We took turns shooting the pictures with Santa we sold to their parents, wiggling our hips at the Dads.

Santa had his own white beard, which he invited all the kids and their Mamas to pull while he patted his big gut, his legs in their black boots wide apart.

"Ho, ho, ho," he cried, with a slap to his belly as he sat on his throne, reaching out occasionally to goose a passing Mom, who'd turn around in confusion, sure that Santa couldn't possibly have done that.

"Ho, ho, ho!" His voice echoed through the mall

without the help of microphones. He lived for Christmas, when he could come back from wherever he hid all year while growing his whiskers and feeding that stomach to get ready for another joyous season.

It was after ten o'clock on Christmas Eve when I saw you. Most of the stores were closed and the mall was about to shut down for the next day, something that only happened once a year, when you come out of Lilian's Lingerie holding one tiny bag, a smile on your lips as your eyes sought mine. By then I was the only elf left, sitting on Santa's knee, too tired to bounce, while he lazily tweaked my nipple and sighed.

"I wish I could stuff your stocking," he mumbled in my ear.

"I don't wear stockings," I answered with a kick to his leg as I jumped off and did the splits for you while you laughed and applauded, the small sack from the lingerie shop dangling from your wrist.

Our Santa loved having his throne in the center of the mall facing Lilian's Lingerie. "Ho, ho, ho, little girl," he called to you. "One more customer for old Santa before he flies away to the Bahamas until next year?"

"I think not," I muttered through my teeth while rolling my eyes at you.

"Oh, ho!" said Santa with a slap to my butt. "So that's how it is—you want her for yourself. Well, Santa wasn't born yesterday. He knew all along your sexy bouncing was just part of the act, so run along, and a Merry Christmas to both you little sluts! Ho, ho, ho!" While Santa slowly rose up from his gold-papered throne, I grabbed the black velvet sack of goodies that he kept by his feet.

"Hey!" he called as I took your arm. "That's Santa's sack!"

"It's the mall's," I shouted. "I'll turn it in for you on the 26th when I take back my costume and pick up my check."

"You won't need to come back for your Christmas bonus, ho, ho!" Santa waved and winked at us, and you winked back, which made me laugh as we ran down the empty corridors of the mall. I should have wondered why you were so willing to go with me, even taking my hand in the brightly lighted parking lot to pull me close.

"Where's your car, Riki?" you breathed in my ear. I was surprised you knew my name, since we hadn't been introduced.

"Is a ride all you want?" I asked as I stood on tip-toe to kiss you.

"To start," you replied.

My heart jumped as I looked into your glittering blue-green eyes. "Do I know you?" I asked.

"No, but I've been watching you play elf since the day after Thanksgiving."

"Where do you want to go?" I asked when we were in my old Toyota.

You leaned back, relaxing into the broken seat that made it impossible for my passengers to sit upright. "Anywhere you want."

"I'm sorry about that seat." I cleared my throat. "Is my place all right? My roommates are out of town."

"Perfect," you said, rolling your head against the backrest. I wasn't sure whether you were talking about my flat or the seat, but I didn't want to spoil the mood with more questions, so I just drove off.

"Great place," you said in the hallway of my flat, removing your coat and red beret, then shaking out your red-gold curls. I heard a tinkling sound before I saw your bracelet ringed with jingle bells, and, when you pulled off your boots, the matching bracelet on your ankle. I pranced in place, still wearing nothing but my elf costume because in my haste I'd run off

without my coat, so excited I was oblivious to the cold.

"Hey, let's go in my room and turn on the heat," I said, meaning that very literally, but your laughter pealed out almost as loud as Santa's, mingling with the bells on your wrist as you pushed back your hair.

All the rooms in our old flat had small gas heaters, so I hustled you inside, dropping Santa's sack on the floor beside my bed, and lit the gas with a long match, watching as the flames sprang to life behind the fiberglass window. You prowled around the room in your bare feet and a long sweater that I guess was a dress since it covered you almost to your ankles.

Because I traveled light in those days, there wasn't much to see. The bed was a mattress on the floor, orange crates were stacked to make bookshelves against one wall, and on top of the antique trunk where I kept my clothes was a candle in a wine bottle with rivers of varicolored wax dripping down its sides. When I knelt to light it, you knelt beside me, taking my hands in yours, running your fingers over my smooth short nails.

"Let's see what Santa's got in his sack," you said as you led me to the bed.

The room was warm enough for me to pull that

long sweater over your head and push you down on the bed, where you stayed, smiling up at me, a green sparkle in your eyes. Devil or angel, I thought, thinking of that old song. Which were you?

One thing I did know was what was in that sack: cheap gifts for the kids, toy rockets for the boys and small plastic baby dolls with smooth round heads for the girls, as well as candy canes, peppermint flavored red ones and cinnamon flavored green ones. There were lots of the green because he liked to slip them to the Moms. "Hots for the hot," he'd say as their mouths dropped open.

I bit the wrapper off a green cinnamon cane and sucked the end, getting it real slick and sticky all up and down the shaft.

"Let's get you warmed up first," I said, kneeling before you and spreading your legs. I slid that candy cane into you, back and forth, side to side, pulling it up against the back of your clit as I slid it out and in again.

"Mmmm," you murmured, like you could taste it.

I left the cane inside you while I turned Santa's sack inside out, dumping the rest of the toys and candy, as well as two well-thumbed copies of Hustler, onto the bed. I opened the Christmas issue and held

it up so you could see the picture of a woman in nothing but a Santa hat spreading her legs for the camera.

"You look better than this even with your clothes on," I told you as I tossed the magazine across the room. "Poor Santa had to settle for that picture." I thought I'd do him a favor by keeping his magazines when I turned in the sack.

I pulled the cinnamon cane from your cunt and stuck it in my mouth to lick off your juices.

"Oh," you cried. "I'm burning inside."

"Try this." I picked up a red plastic rocket and pressed the switch on the underside, which made it shake and tremble like it was going to take off any minute. I stuck that into your wet cunt, feeling you suck it deep inside. I could hear the muffled rumble of the rocket as you arched your back off the bed and groaned, reaching out for me with your belled wrist, your full breasts shaking. I pulled off my top and tights as well as the elf boots and cap, and lay down beside you. You twisted your fingers through my short dark hair, tugging it while I slowly pulled out the rocket.

"Ahhh," you sighed, disappointed because you were enjoying that, so I sucked my warm fist before

curling it up and gliding it inside, where you were so open it was as easy as slipping in a marble. Up and up into your softness I went until I ran up against the nose at the end of your road, which I gently stroked until I felt the walls of your tunnel contract against my hand. I waited until you were still.

"Let's cool down," I said, sucking on a peppermint stick. I let you suck the curved end until our lips almost met in the middle. When it was good and sticky I slipped it into your melting hot slit, rubbing the shaft over your clit as I thrust it deep inside, hook and all.

"Ooh," you breathed, and I felt you shiver as I slowly pulled it out.

You propped yourself up on one arm. "Now your stocking needs stuffing," you whispered with a throaty laugh. "I'll start with this." You rolled over to reach for the Lilian's Lingerie sack, which you handed to me.

I let the bag dangle from my fingertips. "I don't wear this sort of thing," I said.

"I've been watching you forever and I know you'll like this. Come on, open it up."

I took a peek inside and saw a green box with a silver design of a keyboard, the words "Musical Pant"

scrawled across in gold. I dumped it out on the bed as though it might bite.

"Open the box," you ordered.

"Don't be so impatient. I'm new to this." When I opened one end, out slid a pair of light green silk bikinis covered with a design of elves, wearing nothing but their boots and peaked caps, chasing each other around a rather svelte looking Mr. and Mrs. Santa Claus, who sat on a love seat right where my mound would be, a large ermine trimmed red shawl wrapped around their shoulders, matching hats askew on their gray heads. The elves were only shown from behind or the side, so you couldn't really tell if they were boys or girls, though some of them had definite tits. Suddenly I was buzzing harder than that cheap toy rocket. You pressed my shoulders back down on the bed.

"Let me help." Your hands on my thighs were hot and sticky, and I could smell the spice and mint in the air as your wrist bells tinkled. You slid the pants over my feet and up my legs, then pressed a lump in the elastic. "Listen," you said, with a finger to your lips.

Jingle Bells tinkled mechanically from my snatch. Your laughter was like bells blending with the music, which slowly faded as you took your finger away.

"Music for your box," you said. "It's a microchip, look. Press it and . . ." The music started again. As it stopped, your fingers slipped into the panties to roll around my clit. "Now there's two buttons to press," you said. "Are you ready for something more?"

You reached on the floor beside the bed for Santa's empty sack and pulled out the braided velvet drawstring from the top. "First I'll have to make sure you'll lie very still." You held my hands over my head, wrapping the black velvet braid around them. Then you slipped down the musical pants, picked up the damp peppermint cane and put it in my wet cunt, where its cool glow tickled my insides. With your free hand you rummaged in the pile of toys on the bed, choosing one of the plastic dolls dressed in a red satin dress.

"Toys for little girls." You twisted the candy cane, then pulled it out, sucking it into your mouth, licking the taste of me from it as you pulled my musical pants all the way down my legs. You took the dress off the doll and licked the molded plastic curls on the top of its head before sliding it into me, whispering, "Baby wants you."

Baby was a snug fit, but remarkably smooth and slippery, filling me comfortably, pressing just right on

all my favorite spots. Up and up went Baby as my muscles contracted against it. Then I heard the buzz of one of the rockets, and felt the hard quivering plastic pressed against my clit. Far away there was music, Joy to the World, as something else pushed into me, something that felt like a much larger fist than yours, twisting Baby around inside me while you pressed the rocket to my clit. I felt a familiar tweak to my right nipple just before my whole cunt pulsed so hard that the fist and Baby both popped out while a loud, familiar, "Ho, ho, ho!" rang out.

I opened my eyes. "Santa?" I said, but you were the only one there, your smile and your twinkling eyes mocking me.

"In bed with an elf," you laughed. "It's come to this, Riki." You pulled up my panties and pressed the microchip again to play Hark! The Herald Angels Sing while I tried to remember your name, thinking I must know it if you knew mine.

I remember your hands ruffling my hair, and your laughter, and then Santa's again, but everything faded with the music until daylight slashed across my eyelids from the open blind. I was alone, covered with my warm quilt, my hands bound loosely enough for me to easily slip off the velvet tie. I got up, wrapping

the quilt around me because someone had turned the heater off and it was freezing. I lit the pilot again, then saw that Santa's sack with its toys was gone, along with the copies of Hustler and your clothes. My elf costume was neatly folded next to the burned down candle on my trunk. It was as though you'd never been there, but I still had the tie to Santa's sack as well as the silk musical pants, and when I pressed the chip in the waistband, Jingle Bells played again. Stuck to the side of my pillow was a green candy cane, which I picked up and put in my mouth, tasting the last of your sweet cunt along with the cinnamon. That's when I thought I heard a far away "Ho, ho, ho" from Santa.

The day after Christmas I took my elf costume and the drawstring from Santa's sack back to the mall. "This isn't ours," the payroll clerk said, handing the tie back to me with my check.

"It's from Santa's sack," I told her, but she shook her head. "That's not from one of our sacks," she said. "He must have brought his own."

Across from Lilian's Lingerie, a crew was already dismantling Santa's throne.

"Did Santa leave already?" I asked one of the guys, wrapping the velvet tie around my wrist.

He laughed as he said, "Who knows? Maybe he ran off with his girlfriend."

"Yeah," said another one of the workers, "The one with red hair. Bells on her fingers and bells on her toes. Ding dong."

"Did she work here? I never saw her."

They all laughed. "Depends on what you mean by work," one of them said.

Santa and—I didn't even know your name. How did you know mine? I still had on the silk panties, and subtly pressed my groin so I could listen to a muffled Hark! The Herald Angels Sing as I walked through the mall.

I never worked at that mall again, but for years I'd go back at Christmas to see if I could find you, fighting my way through the shoppers while different elves tumbled around a new Santa who looked much thinner and younger than your Santa, with cotton whiskers that drooped down his neck and a microphone on his throne to carry his reedy voice through the mall. I missed the old Santa's raucous laugh and mischievous hands, but most of all I missed him because I needed to ask him how to find you again. After awhile, I wasn't even sure you'd really been in my bed.

The night the microchip finally wore out, I felt it burn my skin as Joy to the World sputtered and faded. Still, whenever I put on the formerly musical pants and wrap the velvet tie around my wrist, I can hear Santa's laughter making a counterpoint to the distant jingle of your bells. I suspect I won't see you again unless Santa wants me to, but meanwhile, I can stroke my pants and wonder if a gift once given can return.

Gone with the Wonton

Shari J. Berman

Eye contact would barely describe the interaction. The woman did a full-blown pantomime across the room. She was flirting with me like a silent screen star, as if Rudolph Valentino had been reincarnated as a large butchy lesbian and had ended up across from me in a turn-of-the-millennium Manhattan bar.

I couldn't see the color of her eyes, but she had an overgrown teddy bear quality. Something about this game made me shudder despite the distance between us. Yvonne put her leather jacket around my shoulders thinking I was cold. I would have preferred ice cubes on my forehead.

I caught the butch's eye again. She mimed tears. It took me a second to realize she was lamenting the fact that she thought I was taken. Yvonne and I had been buddies for years and we touched easily. There had never been any sexual energy between us, though.

Women crowded the dance floor and my view of drama butch was obstructed. I was still on Seattle time, but I assumed that Yvonne was beat. I pointed to the door. She nodded. I stood and tried to give her back her leather jacket, but she helped me into it instead. It had B.A.D. emblazoned on it in huge red letters. It felt welcoming. I had only been on the ground in Manhattan for five hours, but according to the wrap I donned, I was already an official Big Apple Dyke.

As we made our way to the door, I looked around for my role play partner, but I didn't see her. Maybe next time, I thought. I was in town for six weeks of R&R. I had debated going somewhere tropical, but Yvonne had convinced me that December-January in New York would be fun. I was looking forward to days filled with shopping sprees and lattes dusted with vanilla sugar. I craved something sweet; the burnout I'd been experiencing in my West Coast

mental health career had left a nasty taste in my mouth.

I offered the jacket back to Yvonne again when we stepped out into the chilly night air—she refused. As we headed to the next avenue, I put one leather-clad arm around Yvonne. "I wonder if I should have stayed longer and met you back at the apartment," I said.

She wriggled out of my grasp and turned to face me. "I didn't mean to rush you. I thought you were tired from the trip and wanted to go. I always stay until after midnight."

"So, I guess I was the one rushing you. It's after 11:00... and a school night and all," I said with a grin. "I figured you were tired. I'm not that experienced with the bar scene, so I don't know how long you're supposed to hang out. It's probably just wishful thinking, but there was this woman there..."

"You sly dog! How the hell did I miss that? I was watching you when I danced with Jackie and I was only at the bar for a few minutes..." Yvonne tugged on the bottom of my jacket as we neared the bright lights of Broadway. She commandeered a taxi in native fashion and urged me inside.

I told her about the subtle flirting with the woman at the bar. She said it sounded like Kacie Trent.

According to Yvonne, Kacie was a character actor. Actors often changed their names; I tried to imagine what hers was before it became Kacie Trent.

We were quiet for several minutes. I took Yvonne's hand. She was doing so well. She'd just gone through an ugly break-up and I knew she was still hurting. She'd brought me up to speed on the latest antics of "that bitch" over the phone. Yvonne rubbed the top of my hand with her thumb. "Nat, did you ever think about what you and I might be like together?" she asked.

I jumped slightly at the question. "Sure. We'd be good together, but not great. We'd end it all in some awkwardness that would obliterate the best friendship I've ever known. I see myself playing bridge and shuffleboard with you in my 80s..."

"At the Gertrude Stein Home for Aging Jewish Lesbians?" Yvonne asked.

I began to laugh. "I can just see us. You'll be telling them the matzo ball soup isn't hot enough."

"And you'll be there making sure that the Discovery and History channels come in properly on the big screen TV for you and the rest of the nerdy intellectual old biddies."

"And maybe ogling the duty nurse."

"That we could do together. If you're really not that tired, why don't we grab a bite?"

"Great. I vote for Chinese."

Yvonne let the cabbie in on the change of plans. He grunted; muttered something in a language I couldn't place and took a fast, wide, right turn down a one-way street that caused Yvonne to tumble into me. A few hours earlier, I would have been cursing him and writing down his medallion number, but I had transitioned into vacation mode and this made me giggle, instead. Yvonne joined in. We stayed out late talking about old times. Break-ups and burnout never entered the discussion.

\#

Five days had passed since the night at the bar and I'd gotten into the swing of things. I had spent each morning working on an article I was preparing for a professional journal and every afternoon being the quintessential shopper. I was far from alone. The tinsel and holly count appeared to escalate by the minute and merchants seemed to lick their chops at the dollar signs they saw in the eyes of holiday consumers.

I had only bought two gifts and was not as loaded down as usual when I passed the toy display in an old department store. The queue of chattering children waiting to share their wish list with Santa caught my eye. I found myself staring at Santa…except for a far thicker middle, he was built like Kacie.

Jeez, I was really going around the bend. I'd already had an argument with Yvonne and told her to reexamine her fat phobia. I'd always had "a thing" for big women. I once had read that working class Jewish children had fewer fat issues than other groups. Although I was a successful professional, my upbringing had been more working class than Yvonne's. Checking out Santa Claus, however, seemed to be a new low.

The whole idea of Santa Claus bothered me, anyway. As a non-Christian and someone in the mental health field, I found the story of Santa a lot to ask children to buy into. And then what about the separation anxiety when they had to let go of the concept a few years later? I was in trouble. First, I was cruising St. Nick and then I was psychoanalyzing Christmas traditions. I steered myself over to look at books across the aisle.

A few minutes later, I returned to the toy depart-

ment to seek out the ladies' room that I'd seen nearby. All the stalls were taken, so I had to wait. The third stall opened up and I almost lost my teeth. Santa came marching out of it. Santa was a woman? As if I weren't confused enough already, she winked at me before heading to the sinks. I latched myself in and proceeded to take care of business. I noticed a huge black belt with a silver buckle on the hook. I hurried through everything and collected my parcels. I couldn't have Santa losing her britches.

When I got to the sink, Santa had removed her beard and was washing her face. "I think you forgot…" She turned toward me. It was Kacie from the bar. I stopped dead in my tracks.

"Thank you," she said. "I never forget a favor…see… I know you; you're that dame from the other night. Yeah, the one at the bar." She was standing there in a Santa suit using her best Edward G. Robinson imitation on me. I was already battling a variety of stereotypes and confusions. Did I need one more?

I nodded mutely. I watched as she fixed the beard back onto her face. "Ho, ho, ho," she bellowed, vocalizing herself back into character. Someone walked past us and exited. An eerie calm fell over the rest-

room. Running toilets and sinks had come to a halt and Kacie and I were alone.

She pulled me into the lounge area and plopped down on the sofa, dragging me with her. "If anyone comes in, just start telling me what you want for Christmas," she advised huskily. I was now sitting on her knee. "I don't know if Santa can fulfill your wish. I know you've been BAD. You're even advertising it."

"Huh?"

"That's what it said on your jacket. I followed you when you left the bar the other night. I saw you with your girlfriend and I knew you really were BAD."

"That's some kind of club, B-A-D, where the Big Apple Dykes get together. I think the extent of being bad is bringing something lousy to eat to the potlucks."

"If that were a punishable offense, you'd have even more lesbos in the prison system," she confirmed with a wiggle of her tacked on white eyebrows. I noticed they were damp. She hadn't removed them when she'd washed her face. The alarm on her large-faced sports watch started to ding and I shot up off of her at the foreign sound. "My break's over. What are you doing for dinner?"

"Nothing," I replied before I had a chance to

weigh the pros and cons of a night with Kacie. "Are you even planning to ask my name?"

"Natalie. Jackie told me you were visiting from the West Coast."

"I see you're quite the detective, Kacie. You should have known I wasn't a local 'baddie' then."

"I wanted to have you clarify that yourself, you might have earned that BAD label," she said putting the huge belt around her waist. "Seems you've gotten my name, too. You get my number?"

"I think I have your number, all right."

She chuckled softly as she made final adjustments to the suit. "How about meeting me at Mama Cicone's on 38th and Lexington. It's a new place…think Melissa on the CD player with some killer homemade pasta…lesbian chic."

"Sounds intriguing, what time?"

"7:30?"

"Cool."

I thought about just hanging out in the department stores and killing a few hours that way, but I ended up going back to the apartment and dressing for her. I'm far from textbook femme, but it was clear in my mind that I was experiencing a stellar attraction to someone I had pegged as a butch's butch; she

was playing Santa Claus for god's sake… she probably knew how to fix her own car, too.

I dabbed vanilla musk behind each ear and studied myself in the mirror. I was wearing a silk blouse and wool slacks, belted at the waist. I had an ascot around my neck. I felt sophisticated. I'd put my hair up, but wisps were escaping. I decided it was a fashion statement. It gave it my hair that Jennifer Aniston quality. I touched up a few shadows under my eye with a cover stick. It actually worked better on that than it had when I'd bought it to hide a blemish.

I arrived at the restaurant exactly five minutes late. She was already there. She pulled out the chair for me and gave me a debonair bow. Minus the red suit, close-up, she was even more intriguing than I'd remembered. There were vegetable sticks on the table. She put a carrot between her lips and twisting it said, "You seem quite a bit more dressed up than you were in the store, doll…very nice. Very nice, indeed."

"I assume that was your Groucho Marx impression, but anyone younger than I would think you were doing Bill Clinton. May I suggest you be careful what you do with your cigar!"

She blushed a deep crimson. Regaining her bravado she went on, "Younger than I? English major?"

"Some of us psychologists are actually literate, too," I replied with a sigh.

She made a loud crunching noise with the carrot. "I'm sure you're having a field day with me and the phallic symbol."

"I'm not too much for Freud and that bunch...too male-identified. Tell me about the acting career."

"Well, I'd say you've seen how low I've sunk. I had a couple of commercials last month, but things have been really slow since right before Thanksgiving. I had the choice of playing Santa or going on unemployment and I figured the screaming kids were better than the snooty government employees mumbling 'lazy ass' as you fill out the applications."

I couldn't say exactly where the time went. She'd told me the story of her life with an occasional appearance of Kirk Douglas, Joan Crawford, Cary Grant and a whole slew of oldies but goodies. "I know you're taking a break from an overwhelming job, Natalie, but is that all? Some people take breathers when there've been bad relationships they need to distance themselves from."

I smiled. "You're good. How did you manage to avoid a career in psychology?"

"I had a real moron for Psych 101 and I was gaga

over Cindy DeGrande, the belle of the drama department." She smiled at the memory, but it didn't quite reach her eyes.

I knew how dazzling she could be when her eyes lit up, so I went for an obvious ego stroke. "You seem very talented to me…did you really opt for drama just to please Cindy?"

"I love acting. I also loved Cindy; she was my first. She was heavy into denial about being a lesbian, but we spent most of one college semester in bed together. It was like she thought she'd have an epiphany at orgasm number one hundred and fifty, or something." She managed a mirthless laugh. "Lots of people confuse quantity with quality; it's a common mistake."

"She lost out big time," I said.

"Well, you got the big part of it right."

My mouth opened but words did not come out. She jumped right in. "I'm kidding. Rent a sense of humor. You got me strolling down memory lane and completely avoided the reason you've landed clear across the country."

"I said you had a good point, but it really doesn't apply to me. I'm not on leave from a bad social situation, exactly; I'm taking a break from no social life.

I was working so hard I'd given up dating all together. I needed a change of venue for a whole new outlook on things."

"Does that mean, you're available for a date, Shhweetheart?" she asked me, Humphrey Bogart style.

"I thought this was a date and sorry, I can't imitate Lauren Bacall."

"This was a pre-date. If you let me buy you some coffee down the street, we can call that a real date." I smiled and nodded. The next thing I knew we were snuggled together in a dark café booth.

We were sipping our second round of decaf cappuccinos when I glanced at my watch. It was 1:00 a.m. I dreaded the idea of coming in at this hour and having to debrief Yvonne. "It's getting late," I said. We both stood and were out on the street a few minutes after that.

The café was just a few blocks from her place. She'd told me that earlier. We started walking in what I thought was probably the direction of her place. Kacie took my hand and pivoted to look at me under the streetlight. "You can go or you can stay…I'll understand it either way."

The rhyming line had been delivered in a queeny cartoon character voice that I was having trouble placing. I didn't answer... "Snagglepuss!" I blurted out triumphantly.

"But you can call me, Snagglepussy!"

"Sounds messy."

"Maybe. That's for you to find out." She cocked her head. She was sweet and cuddly and hot and sexy all at the same time—it turned my insides to jelly. I nodded. "Exit, stage right."

\#

I've always found that kissing predicts a lot in a relationship. The first kiss reminded me of the best spring rolls I'd ever eaten. They say you can foretell the quality of a Chinese restaurant by their spring rolls—in the same vein, I could imagine what making love would be like with Kacie from her exploration of my mouth. The slightest probe from her tongue sent tingles of pleasure throughout my body. Just necking on her sofa felt like plenty of action for the night to me, or so I thought.

I felt her fingers hesitate slightly on the top button of my blouse. I heard myself gasp. My brain remind-

ed me that I could have removed her fingers gently and kissed them, but the dull ache starting in my stomach and creeping lower and lower talked me out of anything rational. She undid the buttons and I felt us getting more and more carried away.

I sat up and tried to get some air. My brassiere was practically choking me and my nipples were so clearly standing at attention, that I contemplated saluting them. Kacie undid the buttons at my wrists removed the shirt and untangled my bra, freeing me from my clothing. She ran her fingertips across my back. "You're so sexy, Natalie." I shivered. "I want you. I want all of you."

"I've never done this on the first date," I said. It was true, but the sound of my own voice wasn't even convincing to me.

"It's our third date. We had the restaurant, the café and now here."

"I thought you called the restaurant our 'pre-date'."

"When one finds oneself in a compromising position my dear, the pre-date and post-date can all be counted separately." It was Clark Gable talking to Scarlet.

"Just don't tell me you don't give a damn," I

mumbled weakly.

"Let me show you, just how much of a damn I give," she growled. "I also give good head."

I've been with at least a dozen women. Sex usually starts out a bit shy and awkward for me when I'm with a new person and picks up from there. Kacie, on the other hand, knew her way around my body immediately. She had a built-in divining rod that found every erogenous zone with little prompting.

The backs of my knees are quite ticklish and she glommed onto that. I started bucking and she continued the knee tease, while kissing the inside of my thigh. She trailed her other hand down and combed through my sopping bush. When her thumb finally found my clitoris, I was sure it was several hundred times its usual size.

I was moving to the rhythm of her thumb and certain I was on the road to climax when she let her hair brush against the underside of my belly on her way to bring her mouth down to me. I know I sounded like the old-fashioned radiator in Yvonne's apartment. I hissed and gasped and sputtered. I was actually holding back a bit, I wanted to scream. I'm not one to come quietly.

She was nibbling at me playfully, but I was ready

to rock and roll. I ground my pelvis into her and she cupped my ass and licked harder. I rode the long waves with an uncontrollable wail. So much for decorum!

I fell back, blissed-out on her pillows. I opened my eyes and she was hovering over me. I gave her a long lingering kiss and then pointed out that she was over-dressed for our liaison. I had her breasts in my palms before she'd completely shucked the bra. I rolled us over and lay on top of her. "You're at least twice as good as you said you were, Kacie."

"Thank you, Ma'am. Thank you very much."

I took both of her cheeks in my hands and said, "Can you have Elvis and all the rest of your crew leave the building? As talented as you are, I just want to hear your voice when I reciprocate with every fiber of my being."

I heard her swallow. "You really don't have to do that; just hearing you come made me so happy."

I knew she was being generous, but I'm a firm believer in reciprocity. First, the Robin Williams routines, then the self-effacing comments and now the stone butch number—I was seeing a pattern of insecurity. I had long ago recognized my attraction to large women and as a psychologist, I had done quite

a bit of research on body image issues. Large women often had a lot of outer protection that was shielding a fragile inner core.

"I've been fantasizing all evening about touching you, Kacie. I'm not goal oriented like Cindy…I just want to play…get to know you…get to know Snagglepussy. If it's a lot of trouble, you can just lie back and doze." I had a taut nipple in my mouth before she could protest.

"You even have 'lay' and 'lie' down. I think you were lying about the English major stuff!"

"Lying about it, huh? Suffice it to say I did an English minor. Since we're on this 'lay-lie' thread, why don't you concentrate on getting laid and I'll go over my academic credentials with you later." I felt the gooseflesh break out on her arms as I caressed her. I rested my head between her breasts. I kneaded the flesh around her hips and the goose bumps seemed to multiply. "Do you have any lotion or massage oil?" I asked. She gave me directions to her hall cabinet.

The moans that accompanied my loosening up her muscles were delicious. As they dissipated, I began to hear gentle snores. I'd barely completed my work on her upper body at that point, but I decided

to finish the job at a later point. I had told her she could sleep through it all, but I thought the better of it. If I were going to play King Arthur and extract an orgasm from a stone butch, she was going to damn well be awake for all the festivities.

I lay back and thought about sleep. Sleep didn't seem to be thinking much of me. Between the 3% caffeine remaining in decafs and the hot sex, I was totally wired. I'm sure I could have performed one of those adrenaline rush feats like lifting a car off of a small child. I must have been tossing and turning, because I felt Kacie's arm cover my stomach with a thump. I worried that she was angry and/or lashing out at me in her sleep, but she anchored herself over me and started kissing me all over again.

Lord could she kiss. The spring roll image filled my head once again. Traditionally, spring rolls are dim sum items, not appetizers. Dim sum comes from the Chinese for drinking tea. The snacks tend to be a bit oily; to counteract the oil, a lot of tea is consumed. The tea helps the snacks go down better, so one then partakes of more snacks. That's how I was with Kacie's kisses. The more we kissed the more I wanted to kiss her.

I was virtually drunk from kissing her when I felt

her fingers in my pussy again. I drew circles on her lower back with my fingers. Her mouth left my lips and began to nip at the flesh on my neck. I flashed on flipping us both over, but I was weak; the energy rush of minutes earlier was gone. Once again she was leading and I was more than willing to follow.

"Oh, Kacie," I began to chant. "Oh…"

"That's it, baby. Let me hear you."

The second climax was at least a seven on the Richter Scale. Unlike the first time, though, I was practically asleep before the aftershocks subsided. We had turned over finally and my head was resting on her chest. I planted little kisses on her creamy skin as I let sleep finally claim me.

#

The morning sun was filtering into the room when my eyes opened. She was standing over the bed in her birthday suit looking at me. She smiled.

"Morning," I said.

"I was just looking at you and making sure I hadn't dreamed the whole thing."

"Come back to bed," I said with a yawn. She crawled in and put her arms around me. "Is Kacie

Trent a stage name?"

"I started using it on the playground," she told me with a throaty laugh. "Katie was too cute, Kathy was too ordinary and Katherine Colleen made me want to dance a jig...you can see that I'm not exactly leprechaun size, so I started going by K. C. and then I started writing it all as one name and stressing the first syllable."

"I think you're perfect...perfect name...perfect size."

"Yes, well, you may be slightly partial."

"Slightly."

I had the briefest feelings of morning mouth shyness before we began kissing again. I slid down her chest and took a nipple in my mouth. Her response was instantaneous. I felt cheered on by her shivers. I went from breast to breast sucking, nipping and flicking. I started to shimmy down her belly when she turned the tables again. She thrust her tongue back into my mouth. She cupped the cheeks of my ass and started rubbing herself against my knee. I tried to help, grinding my knee in deeper.

Kacie eased away. I looked into her eyes. I'd never seen anything like this before. Her eyes were smoldering with passion, like something out of a

Harlequin Romance. I reached for her, but she was on the move. She buried her head between my legs. "Kacie, I want…it's time to…" I flashed on the look in her eyes and my body was no longer made up of any solid parts. I melted against her; I melted in her mouth. I may have even passed out, because I can't recall the time between the orgasm of the century and snoring like a sailor…or so I imagined.

#

When I awoke the second time, Kacie was in her Santa outfit from the shoulders down, minus the belt. "I have to be work at 2:15," she told me.

"Jeez. What time is it?"

"Almost 1:00. Want some lunch? I had it delivered."

I got up and suddenly felt bashful. She grinned at me and rummaged through a drawer for a T-shirt. I followed her to the dining room. There were half a dozen white cartons on the table. I perused them with amazement: little ribs, spring rolls, dumplings, rangoons, and wontons.

"Dim Sum," Kacie explained.

I shook my head numbly. What would Jung have

to say about all this? I looked up at her. Santa was munching on a rib.

"Aren't you hot in that thing? Can't you get dressed at the store?"

"You wouldn't believe how easy it is to get a cab, dressed as Santa."

I laughed. I put down the spring roll I was working on and went over to sit on her lap. "You know, it's taken me a while, but I'm starting to believe in Santa Claus."

She stroked my hair. "That's good, because Santa believes in you, Natalie."

I think it was the first time since we'd become lovers that she'd used my name and not a generic endearment. Why had I denied myself a personal life for so long? I wanted her more than ever.

I reached under the coat and was disappointed to find that Santa didn't have a fly. She pulled my hand toward her mouth and sucked on my fingers. I looked into her eyes again and there was barely enough oxygen in the room.

"What are you doing tonight?" I finally asked.

"Working until 7:30 and then my brother's having a party at a Japanese restaurant in midtown…you're welcome to join me."

"We have some unfinished business that I wouldn't want to take care of at your brother's party. Besides, I need to get in touch with Yvonne. I've been a pretty lousy houseguest and she's probably a nervous wreck that I didn't come home or call last night." I had my fingers back and had finally slipped them beneath the waistband of the Santa pants.

Kacie squirmed. "It takes me a while, Natalie. Please don't pressure me." I sighed. She scooped my hand out and put both arms around me. "So, little girl, what do you want for Christmas?"

"I want my new lover to come."

A tear trickled down her cheek. "You aren't very good at this. You're supposed to ask for something for yourself."

"Give me a break; I'm a Jew. I'm new to the Santa thing. And I did ask for something for myself. I can't imagine anything more pleasurable than watching you let go, Kacie." She was blubbering now. "Don't worry, Butchie, I'll be gentle." She playfully cuffed my nose.

"I have tomorrow off," she whispered.

"Great. I'll write 'get Kacie off' in my Day Planner."

I watched Kacie finish getting dressed. When she

was belted in and bearded down, she gave me a key and another one of those dizzying kisses. Then, I was alone among the half-eaten boxes of Chinese delicacies. I dipped a wonton in sweet and sour sauce and looked around the room. In my best stage voice I announced, "Tomorrow is another day!" Maybe I couldn't do Lauren Bacall, but I was a damn good Vivien Leigh.

Reindeer Games

Sacchi Green

The ringing of the phone merged with Kristin's
high-pitched cries as Nick pounded savagely into her.
Kris couldn't form words, couldn't find the breath
she needed to beg "Don'tstopdon'tstopdon'tSTOP!"
But Nick didn't stop, kept driving huge spikes of
pleasure through her, until all sensation merged into
one searing, electric jolt of power.

Nick's strokes gradually slowed. Kris could feel her
lover's deep, shuddering gasps through her own hard
breathing and thumping heart. But a man's voice
rumbled suddenly at the edge of hearing...what the
hell? Oh, the answering machine!

"Sorry, Nick, but it's a bitch out there, and getting worse, three inches an hour the weather guys say. We gotta have another plow driver. Get your ass on down here, okay?"

Kris wriggled until she could get her arms around the ass in question and held tight, but she knew it was no use. "I have to go, Babe," Nick muttered into her hair. "The way I fought like hell to get Christmas Eve, Joe wouldn't call without a real emergency. But damnit, ten years of working holidays so family guys could take the time off...." It was as close as she was going to get, Kris knew, to saying "We're family now." It was close enough.

"I guess his timing might've been worse. Just barely." Kris still couldn't bring herself to let go. "Maybe I could come with you?"

Nick's mouth twitched in amusement at the proffered straight line. Kris always wished she could feel that subtle movement under the tip of her tongue, but if she got that close, of course, other things happened.

Nick rolled free and stood up. "Didn't your mother ever warn you about distracting the driver?" She hauled the blankets up under Kris's chin, stroked the muffled body with a lingering touch from throat to

80

crotch, then headed for the bathroom. No time, Kris knew, for a shower together. But the door was left open and she got to indulge her own private fetish for watching Nick wash herself and her gear at the sink. Those strong, adept hands slicking soap between those powerful thighs.....

"It's not fair!" Kris wailed. "Why do the roads have to be cleared tonight? Why doesn't everybody just stay home?"

"I'm with you," Nick said fervently. "Or if they have to get someplace let'm all drive reindeer!" She passed close to the bed, and Kris managed to get an arm free of the blankets in time to cop a feel of firm ass. Then Nick was pulling on her clothes, hesitating briefly as though considering a good-bye kiss, then turning abruptly away. "Keep it warm for me, okay?" she called back over her shoulder just before she plunged out into the whirling snow.

Well, it _was_ still pretty damned warm, Kris thought, wriggling her hips, but how could she loll around in bed while her lover was out in the storm making the world safe for travelers? Stupid fucking travelers!

Suddenly a memory from her childhood, of listening for sleigh bells on Christmas Eve, drifted

through her mind. And something else, something she'd read, about antlers. Yes! Female reindeer had antlers, just like the males! She remembered now how that factoid had tickled her fancy, several years before she'd realized how much women with a touch of the masculine tickled her libido.

Kris rolled out of bed, wrapped herself in a flannel shirt subtly imbued with Nick's scent, and perched at her drawing table. Thoughts flowed through her fingers, until a line-drawing of a prancing reindeer took shape on a scrap of poster board. "Blitzen," she murmured, thinking of the electric tension Nick could build in her until it crackled like lightning. She shifted on her stool, remembering, as always when she sat there, the first time she had sketched Nick's portrait.

They had met at the cafe where Kris was waitressing, working her way toward a fine arts degree at the University. The moment she saw Nick come in, sweaty and tired from driving the town's road-paving truck, she knew what she wanted. Nick was interested, too, she knew, coming back daily and letting her gaze linger on Kris like a subtle touch whenever she didn't seem to be watching, but it had taken weeks to get beyond casual conversation. Finally, in despera-

tion, Kris had approached Nick with her hands deliberately filled with trays of dishes. Payment for the coffee and apple pie lay ready on the table.

"Thanks," Kris said, jerking her head toward the bills, "but my hands are full. Could you just tuck it into my belt?" Nick's gaze didn't leave hers as strong, gentle fingers slid the money firmly into the waistband of her skirt. "Farther in, please," Kris managed to say, her throat tight.

"You sure it won't fall all the way through?" Nick asked, a bit gruffly.

"I don't think so," Kris said. The dishes on the trays beginning to clatter as her arms quivered. "Feels like it'll just slide right on down into my underpants."

Nick stood abruptly and grabbed a tray from her. "Put those damned things down!" she said. "What are you doing tonight?"

"Drawing," Kris said. "For my senior thesis portfolio. Could you model for me? Please?"

She hadn't actually got around to the drawing part, though, until early next morning. The narrow band of sunlight curving gently over Nick's breast and slanting across her jaw onto her sleeping face made the most beautiful line Kristin had ever imag-

ined.

Now, six months later, Kris cut carefully around the silhouetted reindeer she had drawn. Something about the set of its proud head reminded her of the way Nick moved, the way her head was poised over the strong column of her throat—and the way her groans vibrated through Kristen's mouth right through to her bones when she nuzzled and bit at the tender hollow of that throat.

The scissors were poised at the curve of the cardboard neck. Snip—snip—a bite-sized chunk fell away; and at that moment Kris knew what she was going to do to while Nick was gone. Faintly, too, at the back her mind, a plan began to take shape for what she was going to do when Nick came back.

The urge to bake Christmas cookies had struck her suddenly a week ago, while she was hungry and vulnerable in the supermarket. She'd felt vaguely guilty as she bought the supplies; was she being too childishly influenced by memories of her grandmother's farmhouse kitchen, too perilously close to an attack of feminine domesticity? Once home she had shoved the frozen dough behind cartons of ice cream in the freezer, and hidden the tubes of jewel-toned icing gel among her art supplies.

But Christmas was Christmas, after all. Nick had even brought home a small tree, and Kris had decorated it with intricate paper-cuttings of snowflakes and suns and moons and peace signs. They had hung their stockings, too, or at least their colorful slipper-socks knit by Afghani refugees. Why had she thought cookies would be too—too Donna Reed? The hell with worrying about stereotypes.

While the dough thawed, Kris sketched another reindeer, slightly modified to fit onto the dough in an almost interlocking pattern so that there would be only a few scraps left over. Then, realizing that it would be nearly morning by the time Nick came home, she decided to do her meager stocking-stuffing now.

They had promised each other to buy only small, token gifts, and Kris really hadn't had much choice anyway. A round red pomegranate like a hard, pouting breast sank into the toe of the stocking. Then came three bars of the dark, dark chocolate Nick liked. Last, peering over the rim, came two figures Kris hoped would be amusing rather than just silly; a Rosie the Riveter action figure, complete with riveting-action rivet gun, and a Barbie doll surgically altered into anatomical correctness.

Kris was proud of her sculptural dexterity. She might build a whole installation around the theme if she got a show of her work presented at a gallery. The electric wood-burning tool had etched a vagina into the crotch just the way she wanted it, with little folds of melted plastic along the edges like generous pussy lips. For the asshole, she'd gone in cleanly, with just a hint of puckering around the rim.

Maybe she should produce more, deck them with tattoos and kinky costumes and sell them on E-bay. But this one was personal, blonde hair in a single braid down her back like Kris's own, a tiny silver ring piercing through the left of two breasts whose tips had been teased with a hot needle into pointed nipples.

Kris had been uneasy at first because Barbie was bigger than Rosie, but, as she thought about it now, the idea began to grow on her. She took Rosie out and touched her coveralled crotch with a tentative fingertip. Maybe...but maybe not just yet.

The cookie dough was malleable enough by then to roll out with a floured wine bottle. Kris considered making some more exotic shapes, but decided to stick to the reindeer motif, tracing carefully around her cardboard outline with a sharp knife. When the

dozen golden shapes were baked and cooled she dec-
orated them with elaborate lines and swirls of icing
gel, green and red and blue, drawing harnesses and
reins and fancy trappings until they looked more like
merry-go-round mounts than working sleigh-
pullers. One, though, she left unadorned except for a
nose glowing ruby red.

The snow still fell, and the wind blew harder. Kris
gathered candles and filled jugs with water in case
the electricity went out. She started a small fire in the
fireplace, and lay in front of it wrapped in Nick's shirt
watching the flames leap and twine and lick hungri-
ly at each other.

She must have dozed, because next thing she knew
there was nothing left of the fire but vermilion
embers. She quickly added kindling and logs, won-
dering what had waked her. In a moment, though,
she heard the stamping of boots on the doorstep, and
knew. By the time the door had opened and closed
she was there, unzipping Nick's parka, pulling gloves
from stiff hands, frantically pulling up sweater and t-
shirt so that her own naked breasts could press
against Nick's chilly skin.

"Whoa, Babe, don't knock me over!" Nick's arms
went around her, but Kris could feel the exhaustion

in her body. She eased away and helped Nick shrug all the way out of the parka.

"Just sit down," Kris said, leading Nick to the couch, "and I'll take off your boots. And then I'll show you what I baked for Santa."

"Umm, smells so good," Nick murmured, burrowing her nose into Kris's hair where the scent of cookies still clung. Then she flopped back onto the cushions with a sigh. Kris knelt, unlaced the heavy boots still splotched with snow, and pulled them off, playing it straight all the way. She had different games in mind tonight.

"My pants are wet and cold, too," Nick said plaintively. Kris obligingly went for her belt and got the pants all the way off, but kept her movements businesslike.

"Poor baby, I can tell you're all worn out," she said. "Just enough energy for a bedtime snack."

"Oh, yeah!" Nick said, watching the flannel shirt fall open as Kris stood up, revealing her still-warm, still-naked body. But Kris turned away toward the kitchen.

When she came back she carried a plate of cookies and a mug of milk. "Wow," Nick said, "these are too gorgeous to eat!"

"It's ephemeral art," Kris said. "It's not supposed to last. First you assimilate it with your eyes, and then with your mouth."

"Well, when you put it that way..." Nick's gaze didn't leave Kris's body as she took a cookie, licked at the icing, then bit into it. "Damn, that's good!" She bit again, then once more, and it was gone. She gulped down the milk and then glanced toward the plate on the end table. "How come Rudolph doesn't get all the fancy trimmings?"

"Rudolph is naked," Kris said, "Because I'm Rudolph tonight." She extended a finger to the blob of red icing on the cookie's nose, then smeared the gel onto the tip of her own. "See? And I think I'm growing antlers." She really felt as though something was swelling upward from her head, a weight she could feel all the way down to her crotch, where something else was swelling, too.

"Antlers?" Nick considered her thoughtfully. "I do believe you're right. Nice rack." She kept her gaze fixed resolutely high above the considerable charms of Kris's torso.

A new sort of tension was building between them. Kris knew where she wanted it to lead, but first, the icing tingling on her nose was too much fun

89

to pass up.

"Hold absolutely still," she ordered, dropping to her knees with no hint of submission. She pushed up Nick's shirt and, head bobbing, drew a line of red dots from between her breasts down over her belly to the band of her boxer shorts. Nick inhaled sharply as Kris tugged the shorts downward.

"Keep still," Kris said sternly, "or I won't lick it off!"

"I'm trying, " Nick said tensely, and Kris wondered just how far she dared push it.

She wiped her nose on a flannel sleeve, shrugged the shirt all the way off, and licked on the dotted line all the way down to where Nick couldn't possibly keep still. She could feel her invisible antlers brushing Nick's face, chest, belly, as her head went lower and lower. She could feel something else that wasn't really there, too. If only....

She wriggled her tongue teasingly through Nick's dark thatch, pausing just short of where her mouth really wanted to go. Where, judging by arched hips and fingers tangled in Kris's hair urging her closer, Nick really, really wanted her to go.

One quick lap across Nick's straining clit, though, and then she pulled back. "C'mon, Babe," Nick

groaned, her grip tightening, but Kris jerked free. She flexed her fingers, drew a deep breath, and swatted Nick's muscular thigh.

"Roll over, Blitzen!" she ordered. "I'm gonna guide your sleigh tonight!"

Nick stared up at her. Kris held her breath. Then, with that unmistakable twitch of amusement at the corner of her mouth, Nick said, "You'll need a harness, then, won't you?" and rolled over.

Now Kris stared, not just at the magnificent curve of Nick's ass but at the package her long arm drew from under the couch. "Merry Christmas," Nick mumbled into the cushions. Kris took the package, tore it open, and felt her invisible antlers swell. "It was supposed to go into your stocking," Nick said.

"Don't worry," Kris said, strapping and adjusting as she'd watched Nick do so often through the open bathroom door. "I know exactly what it's supposed to go into!"

And in it went, and out, and in again, until Kris had no doubt at all that she was driving Nick high into the sky. Or that only the chilly wind through her antlers kept her own body from vaporizing like a shooting star.

Christmas morning was dawning in a glory of

rose-flushed sky reflected on new-fallen snow when Kris stirred from Nick's inert, exhausted body. She stood to work herself out of her harness, and glanced toward the bathroom, but she wasn't ready yet to wash away anything, especially the slick gleam of Nick's juices on her brand-new, very own cock.

She brought a blanket from the bedroom and spread it over Nick, glad, as she'd been many times before, that they'd found such a super-long couch at a yard sale. Then, as she wriggled gently under the cover and against Nick's body, she set her gift, her joy and pride, on the end table. The little clinks as buckles and milk mug and cookie plate collided didn't really sound quite like sleigh bells.

But it was close enough.

Hark the Herald Angels Sing

Kate Dominic

My dear sweet Christabel was singing at the top of her lungs, her cries of ecstasy piercing the night as I once more snicked the nasty little golden clamp onto her glistening clit.

"Don't fuck with my wings," she panted, arching up onto her tippytoes when I tugged on the clamp chain. "Pleeeease, sir!!!! I'll never get them on straight again!"

Christabel's wings were about the only damn thing she'd ever have on "straight." I leaned back against the wall, my royal white King Herod robe carefully tucked up into my heavy leather sword

belt—and into the elastic sides of my brand-new packin' Man Panty. I didn't want anything to get in the way of the eight thick inches of kingly rubber dick jutting out of my top-of-the-line strap-on. My little angel was going to get fucked within an inch of her celestial life before we left for our performances in the township's annual living nativity pageant. Since I didn't want to be rushed, we weren't going to have time to change after our private scenario. So, Christabel was wearing waterproof makeup and had enough sticky crap in her hair to hold every perfect-ly-coifed blond curl angelically in place through a blizzard, and I was being careful to work around the impressive display of gauze and glitter wings that was anchored to the steel harness hidden in the corset beneath her lacy satin bodice.

There was only so much working around I was willing to do, though. I'd detached the yards and yards of heavy satin and starched net skirting she'd had hooked to her waistband. Under her watchful eye, I'd carefully drape the whole mess over a dining room chair, next to the noticeably damp white lace panties I'd peeled off her and unceremoniously dumped on the table. Christabel was naked from the waist down, clad only in her silky white stockings

and garters—almost the picture of angelic innocence.

Almost. She was also standing in the middle of the living room, her bound wrists held over her head and clipped to the end of the chain hanging from what was, by day, the heavily reinforced attachment for the ceiling lamp that was presently relegated to the bottom of the closet. Christabel's lace and sequins bodice was unbuttoned just far enough for me to tug it down below her boobs. In the shadows beyond the moonlight streaming in through the picture window, her tightly clamped nipples looked like rosy garnets resting on the silvery platter of her corset cups. I tugged on the gilded chain connecting the nipple and clit clamps. Christabel squealed a high C worthy of the most elegant holiday soloist.

Christmas Eve is such a special time for us. Here in our tiny Minnesota town, as the afternoon gloom darkens to dusk, the town choir puts on old-fashioned greatcoats and capes, and the ladies tuck their hands in furry muffs. The carolers travel through the town, leading one and all to the evening's non-denominational services and the living nativity scene enacted with generations-old tradition at the well-preserved Lutheran church in the center of town.

I rubbed my hand absently over the itchy, but flat-

tering, faux beard I donned for every one of the last five years, ever since the Town Council had decided that since I was the drama coach for the community theater, and since men had played Mary for years at Oberammergau, our fair town could follow that same gender-blind precedent for the Christmas pageant. They didn't add that I was obviously way too butch to do any of the traditional feminine roles. Or that there was a pronounced paucity of men who could remember their lines without noticeable-to-the-point-of-being-embarrassing prompts. So, I was in full drag with the Town Council's blessing. Unbeknownst to them, under my robes, my fake dick was positioned to give me maximum kingly pleasure.

"It's almost dark, Christabel." I tugged gently on her chain, surreptitiously double-checking that we were fully in shadows while she closed her eyes and moaned. "I can hear the music, pretty girl. The carolers are probably only a house or two away. You wouldn't want them to see you, would you?"

"Oh, god!" she gasped, her eyes flying open as she jerked her head from side to side, scanning the room. "Can they see me?!"

I could hear the tears in her voice—part pain from the clamps, part horny anticipation, and part real and

delicious fear that someone outside in the snow might really see through the thick-paned picture window into our darkened living room. I'd been playing with Christabel for over an hour, teasing her, tormenting her, fingering her, and eating her cunt until my beard was tacky. Her pussy was dripping with juices and lube. When I'd heard the first faint whisperings of the carolers on our block, I'd strung her up and put on the clamps.

Now, I could hear the music rising louder over the snow. I'd left a light burning in the upstairs window, so the carolers would know we were home and stop. So their eyes would look up, rather than into the ground floor.

"Good King Wenslaus looked about." I leaned forward and took Christabel's lower lip in my teeth, singing along with the music coming into our yard. "On the feast of Stephen." I bit, tugging on the chains as I whispered into her mouth. "When the snow lay round about, deep," jerk, "and crisp," jerk, "and even."

Christabel moaned into my mouth, whimpering with each sharp tug.

"Am I a good king, little girl? Do you like things deep . . . and crisp . . . and even—handed?" She shud-

dered against me. I grabbed a handful of her hair and jerked her head back.

"Watch the hair," she gasped, panting frantically into my mouth. I grunted and moved my hand to her neck. "Yes, sir. Yes, I like it! Oohhhhh."

The music was much louder now. Outside, moon-lit shadows moved eerily in the softly falling snow as the carolers positioned themselves in front of our window. Christabel and I held very still, in the shadows just beyond where the silvery white light beamed into the room.

"While shepherds watched their flocks by night, all seated on the ground."

I pulled King Herod's royal silk cloth from my belt. "Bite," I growled, holding it to Christabel's lips. "You can spit it out whenever you want—if you dare!"

"The angel of the lord came down, and glory shown around."

Christabel nodded in relief, setting her teeth firmly in the gag. Her eyes glowed with anticipation as the heavenly strains floated into the room.

"Silent night, holy night. . ."

I knelt down on the towels I'd spread beneath us, reaching for my supplies. I snapped on a glove, then

scooped out a handful of lube.

"Round yon virgin, mother and child."

The room was quiet, except for Christabel's deep, gasping breathing.

"I'm going to fist you," I whispered, sliding the side of my lube-slopped hand between her labia. "I'm going to shove my fist up your cunt." I flicked my tongue over her distended clit, diddling her pussy mercilessly. "I'm going to make you come so hard you scream." Christabel moaned, a shudder running heavily down her body.

"Holy infant, so tender and mild."

"Do you think a baby's head would feel this big, sliding through your cunt, love?" To Christabel's softly high-pitched "eeee!" I slid my fingers in. One, two, four, turning and twisting. She was so loose and ready for me. I pressed deep, the way I had so often.

"Sleep in heavenly pe-eace."

"I'm going to fuck you with my hand."

"Slee-ep in heavenly peace."

I rested my knuckles against her, letting gravity help as Christabel slowly, inexorably, let her weight bring her down onto my hand. Her muffled cries vibrated through her body. I kissed her tender nub.

"Angels we have heard on high . . ."

"Let me in, love," I whispered. The warm moisture of her cunt pressed over the edge of my knuckles.

"Sweetly singing o'er the plains . . ."

"Open." I pressed up just the slightest bit. Christabel's tremors shuddered down my arm.

"And the mountains in reply . . ."

"Take me, precious," I whispered, tugging on the nipple clamps again. "Open and let me in."

"Echoing their glorious strains."

As the refrain started, Christabel pressed down, and I pushed up hard to meet her.

"Glo-o-o-r-I-a, glo-o-o-r-I-a . . ."

Christabel shrieked and my hand sunk into her. I felt the waves of a mini orgasm sweep through me as her warm, wet pussy slid down over my knuckles. She hung frozen above me, keening, sucking me into her body while my fingers curled into a fist and pressed against her.

"In excelcias deo. . ."

"Come for me, lover," I crooned, panting as my own cunt contracted again. The refrain started and I twisted my fist, tugging on the chains. Christabel stiffened above me, screaming as her cunt muscles contracted around my hand. I pressed again, and while the swells of "gloria" rang in our ears,

Christabel shrieked into her gag and her pussy juice shot into my face. I squeezed my legs together, relishing the tremors as her gift dripped down my beard.

"In excelcias d-e-e-o."

The final notes faded away, and the sudden silence was deafening. I lay with my head against Christabel's leg, panting. The quiet shuffling outside let us know the carolers were moving on to the next house. As the now distant strains of "O Tannenbaum" started, I slowly withdrew my hand. Christabel shook, moaning loudly as my fingers pulled free. She leaned heavily on the chain, spitting out the gag and looking down at me, her eyes glistening with tears.

"That's a helluva mustache wax, sir," she smiled, with a tremulous little toss of her head. Her breathing was still heavy. I moved my fingers to her breast, tugging softly on the chain. She whimpered.

"I'll smell you all night." I leaned forward, pulling a nipple clamp free and taking her cries into my mouth. As she squealed and arched, I savagely twisted the tip until I felt her tears falling on my cheeks. "I'll think of you each time I breathe in the scent of your cunt." I released the other clamp, kissing her while she cried and shuddered, slowly letting down

the chain to swing softly between her legs, so the full weight was hanging from her clit. When she'd quieted, I leaned down and took first one, then the other, tender tip in my mouth, sucking and teething while I swung the dangling chain with my knee until she was squirming and squeaking and I knew she knew what was coming. I pulled her breasts into place and buttoned her bodice, embracing and comforting her and being so very careful of those damned wings. She trembled when I placed my hands on her hips again.

"Lift your leg for your king," I said softly. She whimpered, sliding her leg up and around my waist. I squatted back, pressing my cock to her cunt, tugging harder on the clit clamp as I pushed it to the side. "I'm going to fuck you now, Christabel. Pay homage to your king."

I opened the clamp. Christabel inhaled so sharply her breath seemed a single motion with her scream. She arched forward into my arms, reaching up to hold tighter onto the chain suspending her, lifting herself, her cries drowning out the distant singing. As she moved, I fucked my cock all the way up into her cunt. I thrust deep and hard, grinding her vulva against me until the waves finally, finally washed up from my cunt and washed over me. I crushed her

tightly to me, panting like I'd never catch my breath again.

Christabel tipped forward in her bonds and hung limply against me. I took her weight carefully, trying to keep my balance enough that I wouldn't muss up her hair or her bodice or her precious angelic silvery fucking wings.

"Thank you, sir," she whispered, kissing slowly and languidly against my neck. "I didn't think you'd do it, Deirdre. I figured you might fuck me like you did last year. But Jesus! I didn't really think you fist me. I mean, right here in the living room, with half the town watching. And me in my angel costume, for godsakes!" She giggled against me, sighing content-edly as I slid my dick out of her and hugged her close to me. After one last long, wet kiss, I released her hands. She rubbed her wrists carefully for a few moments, then she gave me one of "those" looks and helped me straighten my robes. She took a long time making sure my kingly bulges were displayed to their fullest advantage. I was horny all over again by the time she leaned forward and kissed me full on the mouth.

"Thanks for not screwing with my wings. And, um, nice mustache wax." The blush was totally

endearing—as was the screech when she glanced at the wall mirror and saw her makeup. My sweet little angel was back to normal. When she reached for her skirt, though, I gripped her hand and held it. She looked back over her shoulder at me. I slowly ran my hand down the beautiful curve of her ass, teasing just below where that damned wingtip brushed her creamy, rounded curves. My fingertips slipped lightly between her buttcheeks. I grinned evilly. Christabel's eyes widened and her breath caught. I leaned forward and carefully bit just the tip of her ear, just below the diamond earrings I'd given her for Christmas last year.

"Figure out how to secure the wings, hot stuff. Next year, you're taking it up your ass while they're singing."

The quiver that trembled over her bottom was as precious as the blushing "Yes, sir" whispered from beneath her lowered eyes.

"I love hearing you sing," I smiled, patting her bottom possessively. "Now get your damn clothes on and let's get going. We don't want to be late to the nativity."

Christabel hurriedly fixed the last of her hooks and latches and touched up her makeup and hair

with an ease that, as usual, left me awestruck. I grabbed our shoes and we tugged on our boots and coats, and as went out the door, I whistled softly to myself.

"Hark, the herald angels sing . . ."

God, I love Christmas.

It's That Simple

Karin Kallmaker

Nita has no idea what her Santa has in mind. She's such an adorable elf, and the short skirt she's required to wear offends my feminist sensibilities and delights my little butch heart.

It's sexist, she'd complained. I had to agree. Butch me got the cushy sitting down job, and long-legged, curvaceous her got the standing up hard work. But if we wanted to go away for New Years we needed some extra cash. She sits the kids on my lap and I listen to what they want under the tree. I'm not half bad at holding babies, though more often than not the bushy white beard scares them.

Tonight's our last shift, Christmas Eve. I am so tired of holding kids and smiling. Nita's elven slippers scuff across the floor and I'm wishing she could have a rest.

Maybe sit on Santa's lap.

The thing that has always worked between Nita and me is that if she likes it, I like it. If I like it, she likes it. It's that simple.

My friend Emily thinks about it too much. I tell her if a nice dyke wants to get on top just to enjoy the ride. Does it really matter if het privilege might be implied from the missionary position? Especially if they both like it?

I don't think enough, or so I'm told. I'm just a garden variety butch and I want Nita to remember this Christmas Eve.

"That's it, Laney." Nita drops onto the faux reindeer bench and kicks off the torturous slippers. "I'm going to sleep until noon tomorrow."

"What about presents?" I want out of the clunky boots in the worst way, but I can stand them a little while longer.

"We weren't supposed to get presents!" She eyes me suspiciously.

"I've always got a present you can open." I won-

der if she can make out my smirk behind the beard.

She gives me her sideways one-eyed wink. "Oh yeah? What about last night, and the night before, and the night before that?"

"Tired, baby. And you were, too, you know it."

I like watching her shoulders rise and fall when she sighs. "I know. I'll own it."

I pat my lap. "Come have a nice rest with Santa."

She grins at me as she scoots onto my knees. "I've never kissed a girl in a beard before."

I cup the back of her head to pull her mouth down. Her lips touch mine and I feel the zing that straightens my spine. She has such soft, moist lips. And she always tastes so good. I think kissing is underrated as foreplay. Emily can keep her feather dusters and blindfolds, I'll take five minutes of kissing any day.

Nita melts into my mouth. She's all female when she kisses, receptive and aggressive. She invites my tongue, then surprises me with hers moving into my mouth, sensuously twining with mine. She loves to kiss me. I love to kiss her. It's that simple.

The sound of her elf hat whisking across the floor brings me back from the far side of Venus. Her carefully pinned hair is coming down. She looks so ready

for love I could cry.

I have to blink to focus on her face and I hope she doesn't notice. She likes to let me feel like I'm the stronger one, but after those kisses I'm starting to wonder if I can stand up.

"Time to go home," Nita whispers. I watch her fingers untie the top of the striped green and white blouse that was the choice of female elves. The lacing parts and her fingertips move into the opening. The sound of her finger brushing her cleavage makes my heart skip a beat.

I pull her to me for another kiss, turning her so she straddles me. The clownish black gloves keep me from feeling the heat of her back, but I'm not going to take the time to remove them right then. I clutch her hips and hold her onto my lap. She is the hottest thing Santa's throne has ever had on it.

She moans into my mouth, then pulls away. "Okay... don't know how you do that. I'm really tired and you've got me thinking about an all-nighter."

The lights go to half-intensity and I know the security guard will be by soon to make us leave the little enclosure. "Home, then."

As I follow her into the styrofoam and baling wire Gingerbread House where Santa and the elves keep

the extra film and supplies, I tuck the black gloves into the back of the jeans I'm wearing under the bright red trousers. It's good to have the use of my hands back. I unzip my jeans and make a critical adjustment as I walk, hoping she doesn't catch me.

I firmly believe that with all presents, surprise is the crucial element.

She bends over to pick up her tennis shoes from the floor of the little structure. The perfect moment almost gets by me as I lose myself gazing at the pleasure of her curves. There's just nothing better than a shapely woman. There's nothing better than women, any shape. Women do it for me. It's that simple.

I lift her skirt and cup her lovely bottom through the pantyhose. "Don't be in such a hurry."

She straightens abruptly and steps back. "I'm not doing it here, don't be silly. The floor's hard and —"

I silence her with a kiss as I lift her onto the small table. Packets of unopened film smack to the floor. I spread her legs and feel her crotch. I'm not being all that gentle. Gentle isn't what she wants sometimes.

"Laney, it's not that I don't—oh my fucking god."

That's when she feels her present pushing against the thin layer of her pantyhose.

Her hand grasps the toy through the crushed velvet pants. Her mouth parts as she assesses the size.

Suddenly I can smell her and I know she's gotten wet.

I kiss her harshly, tipping her head back with one hand in her hair. She moans into my mouth, then breaks away, gasping.

"You said you wanted a big one."

"It's... it's huge." There was nothing uncertain about her eagerness. If there were I would give her more time to think about it.

"Take it out."

She shivers as she loosens the Santa pants. They fall to the floor and she reaches inside my open jeans. "Laney... it's so big."

"Like you wanted, sweetheart," I whisper in her ear. I hook my index fingers into her panty-hose and pull downward. "I'm going to fuck you with it right here."

She gasps but keeps her hold on the warm, pliant silicon.

I free one leg from the pantyhose and spread her open. "You want it, don't you?"

She nods and pulls it toward her. I really want to hear the sound of my new cock sliding into her, but

I hold back. "Nita. Baby."

She looks up from the toy and I see that her eyes are blank and unfocused. Then her gaze falls to my crotch again and she swallows hard.

"Nita, I want out of this outfit." I take her hand off the cock and put it on the hooks hidden behind the white trim of the jacket.

She sucks in a deep breath and her fingers begin tearing at the Santa coat. I start at the bottom and she at the top, but she is well past halfway down when our fingers meet. She pushes it off my shoulders, takes one look at the tight tank I'm wearing underneath, then yanks that over my head, taking the beard and cap with it.

I pull her hips to the edge of the table and press the length of the new toy against her wet, swollen cunt. "Back pocket, sweetheart."

The look she gives me as she tears open the small packet of lube is a mix of adoration and lust, like she wants to kiss me thank you and tell me I was thoughtful, but she wants to fuck too much to find the words.

In a matter of moments everything is wet enough. Lube trickles past the harness and into my cunt. The tickling sensation lights a new fire in me. I push her

legs wider apart and she hisses.

"This is what you want, isn't it? A nice, big cock." I rub the large head at her opening. I love that moan, the one that says she's already lost in the idea of it being inside her.

She whispers something.

"I didn't hear you, sweetheart."

"Fuck me with it."

"Is that what you need?"

She lifts her gaze from between our legs, then slowly, deliberately wraps both hands around my shoulders.

Her nails dig into my bare back, and she slowly draws them downward. My nipples tighten and I want to feel them against hers.

Fuck the buttons, she was never wearing that blouse again. The fabric gives under my hands as I tear at it. After I snap her bra open I drape my body against hers, loving the feel of her skin against mine. I could have stayed like that for hours, reveling in her skin, but her nails rake over my back and I remember why I have her spread out.

She whimpers in my ear. "Please, Laney. Do it."

She is holding me so tightly. Her nails are digging into my back.

"There you go, baby, do you feel that? Feel it?"

Her hands go down to my hips and she grabs hold as she tips her hips to meet mine. The taut wet slide of something big going into her heat—that sound is like no other.

"Damn it, Laney, fuck me!"

"I'm taking my time. You feel so good to me tonight."

She answers with her heels slamming into the backs of my thighs. I yelp, drive forward and hear a moan from her like I've never heard before.

I like that moan. It's worth giving up listening to the sound of me slowly taking her, and worth the loss of the slow kisses I usually want while I give her long, good fuck.

I push deeply again and hear that hoarse gasp wrapping itself around my ears. Yes, I like it. I like to fuck her. She likes it so much.

I move faster and she moans louder. Her heels pummel my thighs and her nails leave marks I know will be there for days after.

She takes it all. Over and over I sink into her eager, receptive cunt. Her nipples are like rocks and her eyes are squeezed shut. She puffs for breath when I shove in, then lets it out in a shudder. And always with that

moan.

I'd fuck her all night to hear that moan. I don't care about anything else but filling my ears with the sound of her loving the way I fuck her.

I can't tell my moans from hers anymore.

I catch her when she lets go of me and stiffens, grinding herself down on my cock until I can feel the prickle of her pubic hair tangling with mine.

"Are you?"

She nods frantically.

"Come on my cock, Nita. Lover. Please."

"So big, baby." A rising cry. "It's hitting everything, oh god."

"Come. Come on."

She nods tightly, her mouth working. I feel her first gush then, soaking my crotch. I wedge my hands under her ass and lift her so I can move her up and down on my cock. She hisses her pleasure and I feel the second gush.

She is abruptly done, crumpling against me. I slowly pull the slick toy out of her cunt, and she caresses it against my abdomen. I slip my hand down to feel her.

I could play with her open, wet lips for days. They feel like silk against my finger tips.

"I thought... I thought..." She takes a deep breath as my fingers circle her roused clit. "I thought we weren't getting presents for each other. The trip..."

"I ate peanut butter and jelly for two weeks," I admit. "I knew. I knew you wanted it. Want it."

She gazes into my eyes and I feel her hand assessing it again. She nods with a trembling mouth and I push into her again, firmly, this time as my fingers play with her clit.

She falls back on the table with that fantastic moan. I lift her calves to my shoulders as she grips the edge with her hands. Her abandon electrifies me and I feel a surprising clench in my own cunt as she lets out a sharp, needy cry. I stop moving, for just a second, not sure I can go on standing up if I come, too. I can't believe how the sight of my cock spreading her wide open turns me on.

She cries out again and I don't have a choice. I like what she likes. She likes what I like. It's that simple.

I plunge into her with an animal growl and she lifts herself to meet my strength with her own.

"That's right," she whispers tautly. "Fuck me like you mean it."

"As long you want it."

"Fuck me until you come."

"Yes."

"You going to come, baby?"

"Yes."

Little noises escape her with each pounding thrust. "So big. So full. Fuck. Fuck me."

She's biting her lip and I know she's holding it back, trying to wait for me. I'm nearly there. I can't believe that I'm nearly there.

"You better come." She cups her breasts, her voice breaking. "Come now. Take me home. Put me on your lap again—oh. Yeah, Laney, yes!"

I freeze deep inside her, my legs shaking as contractions flow down my body. I feel her coming around the cock and her wet mingles with mine. I love it. All of it. The feel of her and that moan, and the smell of her sex, the slick of her skin. It's all so good.

So good.

#

She looks up at me with her hair falling down around her shoulders, nearly naked, her private, wet places exposed. I'm the only one who gets to see her this way, and I adore her like this. "I thought I was the one who liked the idea of something big."

I blush. "I got it for you."

"Uh huh." She tweaks my nipple and gets a wicked look when I shiver. She gathers her clothes, stuffing them into the pockets of her long raincoat. She puts the coat on with nothing but the little short skirt underneath.

I stand there in a daze as she folds my abandoned uniform and leaves it on the table where we just fucked. I finally move, trying to tuck the cock back into the uncomfortable position down my leg.

"No." She catches my hand. "Just zip."

"I can't zip my jeans with it in any other position. I've tried. I think I bruised the inside of my leg having it tucked in there. Thank goodness for the baggy clown pants or you'd have seen it."

"That was ..." She kisses me sweetly. "Quite a surprise. No, don't take it off, either. Leave it out and put on your coat."

"Honey, I can't walk around with it hanging out."

She opens the door to the gingerbread house. "You only have to get as far as the car. Then I'll make it worth your while."

I gulp and hurry after her. Dignity is the last thing on my mind when she is in the kind of mood that lets her strut ahead of me wearing nothing but pumps, a

skirt and a long coat.

I like what she likes. She likes what I like. It's that simple.

Bridesmaids in Red and Green

Clio Knight

To be honest, Christmas has never been a big deal in my family. I certainly don't recall anything all that magical or special about the Christmases of my childhood. We tried doing the traditional thing for years, sweating it out with a proper roast lunch in the middle of the day despite the blinding Australian sunshine and the rapidly drooping pine tree that Dad had bought cheap from the nearest petrol station. We hung chocolates on the damn thing one year—boy, was that a mistake.

By the time my sister and I were teenagers, Mum gave up the whole idea of tradition. We roasted turkey

on Christmas Eve from then on, having it cold for lunch the next day with salad and our favourite picnic foods. We caved in and bought an artificial tree that wouldn't die on us, and even invested in some half-decent decorations. The kids were allowed to vanish down to the beach in the afternoon, while the grownups watched TV and napped.

My point is, it came as a total surprise when my sister Annette announced that she wanted her wedding to be on Christmas Eve—not only that, but it would be a traditional Christmas-themed wedding in our own backyard. Decorations, a tree, home-baked cookies, every trimming she could drag out of her Family Christmas craft books would be on display.

Who was I to argue? I was just the bridesmaid.

So on the weekend before Christmas, instead of meeting Jason's family with a certain degree of dignity and then throwing a drunken girly hen's night, I found myself in the kitchen, baking gingerbread into Santa shapes and wishing my sister had a Halloween fetish instead. Ever tried baking cookies on a blistering hot summer's day? If she started talking about eggnog, I was going to punch her, bride or no bride. I wasn't entirely sure what eggnog was, but Annette had got hold of a recipe from somewhere.

The first batch of gingerbread Santas had burned badly. I was removing the tray from the oven with much swearing and coughing when the most amazing woman I have ever seen in my life breezed into the kitchen and started laughing at me.

She was tall and curvy, with a cloud of red hair that shone like copper. Her eyes were bright green. "What on earth are you doing?" she said in amazement, when the laughter subsided.

It was a fair question, really. "I'm being a dutiful sister," I said calmly. "Plus, if I die from heat exhaustion and gingerbread fumes, it means never having to wear the bridesmaid dress Annette picked out for me."

The gorgeous redhead laughed again. "You must be Ella. I'm Jason's sister, Jo. I've just flown in from Brisbane." She looked faintly worried. "Your sister's not serious about this Christmas theme wedding, is she? I thought that was a joke."

I blinked at her. "Have you seen our garden?"

We both peered out of the kitchen window, where my dad, Jason and several of our neighbours were busy painting the archway that the bride and groom would stand under. It was red and white striped, like an enormous candy cane. A nine-foot pine tree stood

in a huge tank of water, ready to be set up and decorated with tinsel. Lots and lots of tinsel.

Jo looked a little ill. "So those dresses in the hallway ... those aren't for a fancy dress hen's night or anything?"

I smiled at her, quite enjoying myself now I had someone to share the suffering with. "Oh, no, fellow bridesmaid. Those are what you and I will be wearing on the big day."

"Your sister can't hate me that much," she said hoarsely.

I had thought the frothy gowns of red and green striped satin were bad enough before. But seeing Jo, with her naturally copper-orange hair, was the final evidence that my sister was entirely insane. "You could dye it," I said sympathetically.

"The dress?"

"Your hair."

"What colour hair would look okay with those dresses?" she moaned.

"You could go redder, and I'll take green," I said impishly. "There are those temporary dyes that go away after a few hair-washings."

Jo smiled at me. Her whole face lit up with humour, making her even more beautiful. "Okay, you

124

are now officially my favourite sister in law. I don't suppose I can convince Jason to marry you instead?"

"Not my type," I sighed. You are, I added silently, but managed to refrain from saying it out loud. Hitting on Jason's sister was probably not the best way to welcome him to the family. "How about you help me make something vaguely resembling gingerbread, and then we run down to the shop to pick out dyes?"

Jo surveyed the sad remains of my first attempt at baking. "Honey, we might be here a while."

\#

On the morning of the wedding—Christmas Eve—Jo and I shut ourselves in the upstairs bathroom while my mother and hers fussed over Annette downstairs. Jason was getting ready at his place with his best man and some other mates. As long as they could restrain themselves from chaining him to a lamp post on the way over, everything was going to go ahead without a hitch.

Everyone probably assumed that our mad laughter was the usual bridesmaid nerves and excitement. In reality, we were in absolute hysterics over the fact that

my mousy blonde hair was now bright emerald, and Jo's was a vivid satiny scarlet. It had taken us more than an hour to get our long hair dry, and we still weren't used to the weird effect of the colours.

"My mum's going to kill me," I howled.

"Wasn't your fault," said Jo, admiring herself in the mirror. "Those gingerbread fumes overwhelmed you with the spirit of Christmas. Could happen to anybody."

She looked amazing, as it happened. The dress was a fright, but it hugged her curvy body sensuously. Her cleavage looked as if it were about to burst free of the tight bodice. I had a sudden urge to stroke her bare shoulder, and promptly put my hands behind my back. I'd been flirting with her madly all weekend and she had been flirting right back, but I wasn't entirely sure whether it was _real_ flirting. She seemed the kind of woman who acted that way around anyone, male or female.

"I suppose it's a good thing that I look so terrible," she sighed into the mirror. "Weddings are bad news for me. I usually get depressed and end up sleeping with someone I shouldn't."

"Nothing wrong with tradition," I said lightly, and our eyes met in the mirror.

"Right," she said in a business-like voice. "Let's face the music, shall we?"

We walked downstairs together, the striped satin swishing. "Annette, are you ready for us yet?"

The blushing bride came around the corner. "I want you both to wear a wreath like mine..." She stopped, and stared at us. She looked lovely, her slender body in a traditional full-length white gown. A wreath of green spiky holly and red roses crowned her fair hair. As she took in the bright scarlet of Jo's hair and the green of mine, her mouth fell open.

"Ella!" shrieked a shrill voice as my mother rounded the corner and saw us. "How could you do this to your sister on her big day?"

"Jo-anne!" screeched a similar voice from Jo and Jason's mother.

I felt instantly guilty. I had been so caught up with impressing Jo and making fun of my sister that I had ruined the perfection (all bad taste aside) that Annette had planned for her wedding.

"But I love it!" Annette insisted.

Jo and I stared at her. "What?"

"It's so cute! And your hair would have clashed with the dresses otherwise, Jo, although that's not really your fault, I suppose." Annette darted forward

and hugged me carefully, trying not to crush her dress. "Thank you for getting into the spirit of this, Ell."

I stared at my mother over Annette's shoulder. She was shaking her head, her expression pained. It occurred to me that she probably thought a Christmas theme wedding was pretty stupid too.

"White roses!" Annette suddenly exclaimed. "They'll show up beautifully against the red and green of your hair. I'll pick some from the garden." She fluttered off, letting herself out the front door.

Our two mothers sighed. "Tea, Bernice?" Mum suggested.

"Thank you, Sarah. I think a cup of tea is a very good idea." They headed toward the kitchen, both looking exhausted.

Jo and I stood on the stairs, not looking at each other. "Okay," she said finally. "Obviously insanity runs in your family."

"Can't argue with that," I agreed. "Of course, since Jason chose to marry her of his own free will, poor judgement obviously runs in yours."

Jo sighed. "Suddenly, I have a craving for gingerbread Santas."

"I think there's some eggnog in the kitchen."

"Let's go."

\#

Annette and Jason were married in front of a candy cane arch, with a giant Christmas tree looming over the guests. My mother had been sensible enough to call in caterers to provide the main food for the buffet (roast turkey, what else?) but everyone agreed that the homemade eggnog and gingerbread was a really nice touch.

Jo and I stuck together for most of the reception. Our costumes were less embarrassing when there were two of us. Well, that was a good excuse anyway. The truth was, I wanted to spend time with her. Of course, I had no way of knowing if she felt the same way or was just being friendly.

At one point, Jo grabbed my sleeve and pulled me back behind the Christmas tree. "Hide here for a minute."

"Why?"

"I'm trying to avoid the best man, he's an ex of mine."

Ah. Well, there was that question answered. It was probably for the best—now I could just concentrate

on being friends with my new sister-in-law.

She turned to me and smiled mischievously, her fingers entwining with mine. "Life is so much less complicated since I gave up on men."

I stared at her with a mixture of surprise and hope. She laughed in a low voice, and leaned forward to kiss me. Her lips were as soft as I had imagined. She tasted of gingerbread, which I was rapidly becoming more fond of. The predominant smell in the air was the chemical hair dye we had inflicted on ourselves.

The kiss became deeper, more involved. Her hand slid over my breast. We came up for air, gasping. "How many washes did the packet say we would need before the colour came out?" Jo asked, sounding breathless.

"Six."

"Let's get started."

No one seemed to notice the two bridesmaids slip away from the wedding reception which is odd, because we were hard to miss. Still, a turkey buffet is a good distraction.

The orchestra started playing Silent Night as Jo and I ran up the stairs to the bathroom and locked ourselves in, kissing and giggling, kicking off shoes

and pantyhose. We tried unlacing the gowns but it required far too much in the way of hand-eye co-ordination.

"It's not like we're ever going to wear them again," said Jo.

A fair point. The photographs had been taken before and immediately after the ceremony. I leaned over and turned the shower on. "I don't know. We could always cut them down and wear them to other formal occasions. Or sell them... there must be a big market in Christmas weddings."

Jo laughed at me and clambered into the shower, dragging me after her.

Watery dye, red and green, poured around us. The satin was clingy and wet around our bodies. I did what I had been wanting to do since I first saw Jo; I cupped her amazing breasts in my hands and bent down, taking her nipple in my mouth, sucking at it through the satin. She moaned, suddenly serious. I went down on my knees in the shower, lifting her heavy, wet skirt and trailing my hands up her thighs. She had conveniently removed her undies with the pantyhose, leaving her pussy bare and ready for me.

The hot water of the shower rained heavily around me as I put my lips to her, parted her with my

tongue, sucked at her sweetness. She swayed slightly, but stayed steady. "Thank goodness for handrails!" she laughed.

I slid my tongue further into her, working her with my mouth. She was moist and creamy. Had she been imagining this all through the ceremony, as I had? My breasts ached as I brought her to a slow, gasping climax. She half collapsed as she came, falling on her knees and staring into my eyes. The water was still streaming scarlet dye out of her hair, down her bare shoulders, in wet red rivulets. She hooked her fingers in my hair and pulled me to her, kissing me with tongue and teeth, fierce and powerful.

"Why don't these damn dresses just unzip like normal clothes?" she breathed, sliding her hands under the wet satin of my gown and squeezing my buttocks.

"More fun this way."

"I want to taste you, not this damned satin," she pleaded.

We hadn't closed the shower curtain. I reached out to the toiletries shelf and located a pair of nail scissors, which I handed to her. "Do your worst."

Eyes sparkling, she slit my gown down the middle, from neck to hem, parting the fabric with obvi-

ous pleasure. She unfastened my bra and tossed it across the bathroom, then bent her wet face to my small breasts, licking the water from them. Her fingers were working lower, slippery and eager, teasing my clit into a frenzy, toying with my labia.

I wanted her mouth on me, and was about to beg for it when she went one better, sliding three fingers into me in deep penetration. Her fingers were long and expert, and it wasn't long before I was exploding with her touch, crying out her name until she kissed me into silence.

Beneath the sound of the shower, I could hear music from the garden as the guests sang along to an orchestral rendering of Ruldolph the Red-nosed Reindeer.

"Do you know what we need?" Jo whispered.

"Please don't say eggnog."

"Conditioner."

I looked at her bedraggled scarlet hair, still no less scarlet, and laughed. Then I located my favourite shampoo and conditioner, and we started soaping each other's hair.

There was a knock on the bathroom door a few minutes later. "Girls? Is this where you are?" My mother.

"Just getting rid of this hair dye!" I called out cheerfully. Two girls sharing a shower, no big deal.

"Well, I did think that was a silly idea. Will you come down soon? We're having Christmas pudding."

"We'll be there!" I yelled.

"Will there be brandy custard with the pudding?" Jo said cheekily as we took turns to rinse out each other's hair.

"Don't forget the gingerbread Santas."

"And the mince pies."

"Marzipan fruits."

"Red and green paper napkins with reindeers printed on them."

"Holly wreaths."

"Fake snow."

"Tinsel."

"Eggnog!" we both screamed in unison, laughing wildly.

I had a feeling that I'd be celebrating Christmas with greater enthusiasm in the future. Maybe there was something to this whole festive tradition thing, after all.

Ho ho ho.

A Christmas Invitation

Anya Levin

Christmas.

A time of frantic mercantilism and sugar-coated platitudes about family and joy. For those who didn't have a warm, loving family to run home to, Christmas was nothing more than another day of depression and loneliness.

For those reasons, Ronnie Dawkins dreaded Christmas every year. It had been three Christmases since she had seen her family – that holiday had ended with a screaming match that would life in her memory forever – and two since she had shared the holidays with a lover. Said lover had, of course, used

the day to drag Ronnie to her own parent's house and then Ronnie had had to sit through an interminable, uncomfortable meal.

Her then-lover had dumped her on New Years anyway, and she blamed the pernicious holiday for that too.

And now it was Christmas again.

Ronnie stepped out of her car and locked the car door before reluctantly shutting it. The brightness of the parking lot light shone on the flurry of snowflakes that drifted down around her, and Ronnie shivered, pulling her jacket closer around her neck.

She looked up at the school and sighed. The school looked just the same as it always did – dull, grey and totally uninspiring. In one hand she carried the store-wrapped gift that she had been required to bring for the Secret Santa gift exchange – one of the principal's so-called brilliant new ideas.

One of the doors opened as she neared it. She ducked into the warm building, and turned to see who else had lingered until the party was almost ready to begin. Perhaps, she thought, seeing the woman who held the door's handle, there would be some benefit to the evening.

"Hi, Ms. Dawkins," she was greeted. Selena was

young and pretty – Ronnie allowed herself a single look-over before meeting Selena's eyes. Inexplicably, Selena's bright, cheery attitude buoyed her spirits.

Together, the two women headed down the hallway toward the staff room, where the party was to be held.

"Hi Selena," she said with a smile. "Even you got dragged out tonight?"

Selena blushed at her teasing. "I like Christmas," the woman said. She nibbled on her lower lip and colored more deeply.

"There's nothing wrong with that," Ronnie said. "Even I like Christmas. I just don't like these damned staff parties," she said, falling back into the dark funk that had defined her day.

"Oh," Selena said. She sounded uncomfortable. "I was just getting a breath of fresh air. Is that your Secret Santa present?"

Ronnie nodded. She glanced at Selena, who was acting most uncharacteristically. "You really get into the Christmas spirit, huh?"

"What do you mean?" Selena asked.

They turned a corner, and Ronnie pushed open the gate so that Selena could squeeze through first.

"I mean that you're awfully cheery tonight,"

Ronnie said, sneaking another glance at the younger woman.

"Oh, that...."

Selena was biting her lower lip again, Ronnie noticed. It made her want to soothe the over-red softness with her own tongue.

Ronnie sighed. The staff room door was a few more steps down the corridor – it wasn't time to be indulging her fantasies.

She opened the door, and let Selena drift past her and into the room.

As she had hoped, everyone was already there. She followed the younger woman in, stopping briefly to put the gift she carried beneath the shabby tree that had been erected in the corner. She watched the other teachers and staff members laughing and talking with each other.

The all-purpose table that stretched across the center of the room was covered with sodas, cookies and seasonally-themed.

"Watch out for the punch," Helena Matthews, one of the seventh grade teachers, warned her as she passed. "I think P.E. man over there spiked it."

Ronnie grabbed a cup and headed for the raspberry-scented mixture quickly. If she didn't hurry

Newmann would catch on and have the stuff watered down.

She tasted the mix. Vodka. Smiling, she topped off her glass and headed off to find a seat in clear view of the clock.

"All right, let's do the gift exchange!"

Cheers greeted Principal Newmann's announcement. Ronnie settled for half-hearted clapping. Gifts were handed out one by one. Helena did the honors.

Ronnie took the gift handed to her and glanced at the clock. She had been at the party for half an hour, but it felt like it had been an eternity. Experience told her that the so-called celebration would wind to a close in another half hour or so – most of them had families waiting, after all – and she would be home soon enough.

The oh-ing and ah-ing had already started.

"Who got you?" Mike Kim asked, leaning over to look at her present. "Hey, you haven't even opened it yet!"

"Give me a minute," Ronnie said, digging her nails into the vivid brightness of the Christmas paper and ripping the package open. It was a box, rectangular and slim. She lifted the top off, aware of Mike's avid attention, and separated the layers of tissue

paper. Inside, buried, was a small ceramic pin depicting a star and a moon. Lifting it gently from its bed in the paper, Ronnie examined the piece.

She couldn't help but smile. Whoever her Secret Santa had been, he or she had known her taste.

"That's nice…" Mike said, a frown creasing his forehead. "Not very Christmasy, though, huh?"

"I guess that means you're not my Secret Santa, doesn't it," Ronnie teased.

Mike smiled and laughed uneasily before heading back into the crowd. She fingered the edges of the pin. He had caught her one weekend having lunch – a very intimate lunch – with her girlfriend, and just hadn't been the same since.

Of course, none of that answered the question that she had actually begun to wonder about. Who exactly was her Secret Santa? The pin fit her tastes so exactly that it had to be someone who knew her well, but that description didn't fit many of the school staff.

Picking apart the box, Ronnie discovered a card. It was buried between the layers of tissue paper. If she hadn't been specifically looking, she never would have found it. Inside the pale cream envelope was a single piece of matching paper. Curiosity piqued, Ronnie turned the paper over in her hand.

It was an invitation.

PRIVATE CHRISTMAS PARTY
Please join me on the evening of
December 24th
For a night of wine, good food and, perhaps,
more...

An address was neatly printed below the elegant
lettering. An unfamiliar address. The card was
unsigned.

Ronnie snorted, but then looked at the pin.

She searched the room, looking for someone
watching her. Surely someone who gave such an invi-
tation would stay to see her reaction! No one was
looking in her direction. Everyone was occupied with
their pens and mugs and gift certificates.

Then she realized that Selena was missing.

The fire crackled and burned. It heated the candles
that sat on top of the mantle and scented the room
with cinnamon and spice. Ronnie sat on the couch,
watching the flames flicker and dance. In one hand

she cradled a glass of blood-red wine. In the other she held the small card that was her invitation.

…Perhaps, more…

It was an intriguing phrase, she had to admit, and that thought that it might be — could possibly be — the sweet little Selena who had issued the invitation made it all the more enchanting.

She took a sip of the wine, and set the glass down on the floor. She savored the lush, deep taste of the vintage and turned the card over in her hands.

Would she go?

The card, she noticed, smelled of jasmine. Did Selena smell of jasmine?

The snapping fire filled the silence as she drifted into her favorite fantasy, a fantasy that featured the sweet little Selena as her very willing co-star.

#

"Let me touch you," Selena whispered. Her voice was low and sweet and erotically tinged with her faint Spanish accent.

The younger woman's fingers neatly separated the

panels of Ronnie's cross-tie tunic, revealing her breasts. Her fingers slowly touched the rigid peaks of her excited nipples.

"You're so pretty," Ronnie told the girl, touching the caramel curls that fell riotously around her face.

Selena looked up at her, dark eyes liquid in the firelight and wide with emotion. "Lay down," she said, standing up.

Ronnie obeyed, watching as Selena stripped her dress off slowly, raising the emerald-colored cotton over her head and letting it fall to the carpet at her feet. She reached behind her and unlatched the bra she wore – she didn't need a bra – and soon that rested on top of her dress.

"Wait," Ronnie breathed.

Selena smiled at her. It was a sexy, teasing smile. She hooked her thumbs into the waist of her delicate little panties – they were green, two shades deeper than her dress – and titled her hips toward Ronnie.

Ronnie's eyes locked on Selena's red nipples. They tightened in the cool air until they looked like two pert raspberries. She wanted to suck them.

"Why wait?" Selena asked, stepping forward until she stood beside the couch where Ronnie lay.

"I want to see you like this," Ronnie said. She

leaned forward, toward Selena's crotch, and smelled the musky odor of the younger woman's desire. Her fingers crept toward the silky emerald barrier that separated her from the cunt she craved.

She moaned, finding the silk wet through with the other woman's juices.

"I want you," Selena told her. She made short work of removing the panties. Ronnie watched them slide down her thighs and pool around her feet. Selena stepped out of them and bent to pick them up. She paused. "Do you want to smell them?"

Ronnie nodded eagerly, and accepted the emerald panties as Selena stood once more. She stuck her nose in the wet crotch and sniffed, inhaling deeply. The scent of Selena's wetness sent a shock of arousal straight to Ronnie's clit. The little nub snapped to attention. Ronnie shifted her hips, craving Selena's touch.

"They're not enough," she said, and set the panties aside.

Selena smiled, showing off her small white teeth and her dimples.

They were on the floor then, and Selena was feasting on her cunt. Ronnie groaned at each expert flick of her tongue, and arched into her mouth. She

touched her own hardened nipples, twisting them and plucking them, feeling the sensation that shot from her breasts down her belly and into her clit.

"I want to lick you," she begged, gasping with pleasure.

Selena twisted, and then her moist, fragrant cunt was in Ronnie's face. She thrust her tongue into the dripping tunnel, tasting the salty sweetness of Selena's excitement. She found the hard clit that nestled between the broad lips and laved it gently. Selena's gasp passed over her over-heated cunt and she smiled, latching onto the bud and sucking it. Selena's buttocks shuddered beneath her hands.

Selena parted her thighs still wider. Her long, caramel-colored hair tickled as it fell over her hips and legs. Two fingers sank into her cunt and began to pump. Her lips and tongue licked and teased. Ronnie shuddered. She felt the pressure that told her that her orgasm was approaching. She pushed her hips higher.

Selena's fingers slid in and out, and her hips moved in rhythm.

Ronnie pushed her fingers into Selena's wetness, then pulled them out and began to stroke the other woman's clit firmly. Her tongue sank into Selena's

cunt. Her fingers slipped and danced as she sucked the woman's juice.

Selena squealed and, pumping with abandon, bit lightly on Ronnie's clit.

With low moan Ronnie came. Her orgasm was so strong that it lifted her hips from the bed. Dimly, Ronnie could hear Selena's own cries of ecstasy, and then she was swallowing the rush of juice that swept over her tongue.

Lassitude overtaking them, Selena turned in her arms until they cuddled breast to breast. Ronnie scooted down until she could bury her face in Selena's belly, and enjoyed the feel of the younger woman's soft skin cushioning her face.

She wasn't alone, and that knowledge was as moving as Selena's open face and obvious desire.

#

The fire dwindled to nothingness and the wineglass lay untouched. Ronnie drifted to sleep. Her fingers were buried in the warmth of her cunt and her face pressed against the side of the couch.

She was smiling.

#

December 24th arrived.

Ronnie awakened to a brilliantly clear morning. The sun shone on the glittering piles of snow and limed the ice-covered trees with radiance.

Drinking coffee from a steaming mug, staring out over the frozen expanse that had once been her lawn, Ronnie considered the invitation.

Truthfully, she had been considering it all week. On one hand, the prospect of getting out of the house for Christmas Eve was very attractive. At the same time, all she wanted to do was crawl in bed and sleep through the holidays, same as she had done for the past few years.

There was also the niggling knowledge that she wasn't absolutely sure that Selena had been the one to issue that invitation.

Ronnie watched the rise of vapor off the snow as she finished her coffee, then cleaned up her cup and plucked the cream-colored card from its place of honor on her mantel. She took it to her computer, where she spent fifteen minutes dissecting the address on it. Within minutes, she had a phone number.

The line rang three times before the answering machine clicked on.

Ronnie breathed a sigh of relief, then listened closely to the woman's voice when it began to speak. Low, sultry, and tinged with a delicious Hispanic accent, that voice cleared up all of Ronnie's doubts about her hostess' identity.

It was Selena.

Ronnie pressed the 'off' button, and smiled, holding the phone to her chest.

Christmas was a miserable holiday, but Selena was a treat that she was going to enjoy indulging in.

#

The streets were nearly empty. Everyone was home with their families celebrating, sharing the holiday spirit. Ronnie parked her car alongside the sidewalk and climbed out. She double-checked the address on the card with the brass numbers that hung beside the front door.

They matched.

She walked up the steps slowly, admiring the well-crafted decking and the cared-for porch. Truly, she had never expected anything less from Selena. She

rang the bell.

The lights were on inside the house. They sent a glow out through the sheer-draped windows and illuminated the night. The door opened slowly.

"H... Hi," Selena said. She stepped back from the door.

Ronnie sniffed the air appreciatively. It was redolent with the odor of roasting chicken and seasonal cinnamon. She stepped into the warmth of the foyer and took off her coat. She could faintly hear the strains of music – music with a distinctly Christmas flavor to it.

Selena hastily took it and hung it up.

They looked at each other, Selena knotting her hands with obvious nervousness.

"Can I have something to drink?"

"Oh," Selena started, then twisted on her heel, "Sure. Come on in the living room. Is soda okay, or do you want something stronger? I have a bottle of wine..."

"Soda's fine," Ronnie said.

Selena nodded. "Good. We can have the wine with dinner."

Ronnie followed the girl, admiring the stretch of her skirt over her rear, and the curves of her waist.

The dress was made of velvety ruby material that clung and shifted at just the right spots.

Selena led her into the living room. An old, faded couch was set against one wall while one corner of the room held a large television, and the other a tall, heavily-decorated Christmas tree. Ronnie examined the holiday decorations while the other woman headed off to find her a drink.

"Here," Selena gave her a glass of ice water, then stood next to her. The silence between them was uncomfortable. Twisting a dangling ornament with a fingertip, Ronnie watched Selena out of the corner of her eye.

Selena's hands were crossed and folded across her chest, lifting her breasts high and squashing them together. The low bodice of the dress that she wore revealed the tanned curves of flesh deliciously, even hinting at the deep pink of Selena's nipples as they strained right below the edge of the fabric.

She looked like a scared, skittish virgin on her first real date, Ronnie thought, feeling a thrill of anticipation shoot straight to her cunt. Then again, she thought, seeing the teeth marks in Selena's full lower lip and the unnatural smile that stretched her lips wide, her stand-offishness could be just plain nerv-

ousness.

What had she been invited for? The invitation suggested erotic play, but Selena was clearly unprepared for that. It was impossible to believe that she had never heard of Ronnie's sexual proclivities. Mike Kim has certainly seemed to feel it a calling to inform anyone and everyone of what he had seen.

A buzzer sounded, and Selena jumped.

Ronnie watched her carefully. She didn't want to scare the girl, but between the rather risqué wording of the invitation and the very inviting glances that had been cast her way before the staff Christmas party, she had been expecting to end the evening by extending their acquaintance into something more personal.

"The chicken is ready," Selena said, smiling shyly.

They passed through another doorway, and Selena drew back a seat for her to sit on. A well-appointed table sat before her, set with what looked like real china.

"This is beautiful," Ronnie said when Selena returned, carrying the chicken on a platter.

"Thanks," Selena said, ducking back into the kitchen.

Ronnie listened to the faint Christmas carols and

the muffled bangs coming from the kitchen. She shouldn't have come.

Selena came back into the room. She carried a bottle of wine and two glasses.

The chicken was good, but all Ronnie could focus on were the mixed signals that Selena was sending out. She had taken a seat next to Ronnie, and when she sat she shifted her legs so that her dress rode up on her thighs, revealing that she wasn't wearing stockings. The realization caused Ronnie to, once again, rethink her dilemma. The heavy silence that fell over the dinner, though, held little hope for a night of pleasure between them.

"I have a confession to make," Selena said, finally breaking the silence.

Ronnie tensed. She was going to say it was all a mistake, or worse, a joke. Anger and humiliation dried her mouth. She swallowed her last bite of chicken down with a gulp of wine and set her fork on her plate. "A confession?"

Selena twisted her fingers together, not looking at her. "I... I asked you here for more than dinner."

Well, that was obvious, Ronnie wanted to shout. She restrained herself. Seeing Selena bent over the table in apology seemed to preclude the eruption of

anger that she felt building in her gut. Of course, the sight of her breasts stretching the fabric of her dress nearly to bursting with the position was a distraction that was hard to ignore. She let Selena talk.

"I've been obsessed with you," she said. "I knew you were alone during the break, and so was I. I… I wanted to be with you." She tossed her head back proudly, but her expression screamed fear.

"You wanted to be with me?" Ronnie probed. Could it be that she was indeed the scared virgin that she seemed to be? Could her tenseness be nothing more than nerves?

Selena nodded. "I've never…"

"Been with a woman?"

She nodded again.

"Poor darling," Ronnie crooned, smiling broadly. "I'll have to show you what you've been missing!"

The other woman looked up, eyes bright. "I fantasize about you," Selena said. Moisture leaked from her eyes and tracked down her cheeks. She sniffed. "I watch you walk down the hall and I get wet. I even keep extra panties in my purse in case I get a chance to talk to you!"

The tears were copious now, and Ronnie laughed, infinitely relieved, as she drew the slight woman into

her arms. Selena fitted into her chest naturally. Her breasts were soft, her thighs hot against Ronnie's legs.

Ronnie led her into the family room and to the couch, where she plopped down. Scanning the room, Ronnie found the CD-player. She reached to turn off the music.

"Don't," Selena sniffed. "Please don't."

Ronnie looked at her questioningly.

Selena blinked and rubbed her forehead. Faint mascara tracks trailed down below her eyes. She looked crumpled. Beaten. Ronnie felt something shift in her heart. Not pity. Not compassion, but something more painful, and more sympathetic.

She pushed the unwelcome feeling away. She wasn't looking for forever.

"Are you sure that you want to do this? If you're just looking for a friend…."

"No," Selena said. Her voice was getting stronger. "I'm not looking for a friend. I have plenty of friends. I'm looking for you, Veronica." She blushed. "I looked up your name in the staff register."

Ronnie laughed, but couldn't ignore Selena's impassioned tone. "I'll love you – gladly – but I can't make any promises. Are you okay with that?"

"Would you stay with me tonight? Just until…

until tomorrow. Until Christmas is over?"

"Yes, yes I will."

The festive red and green lights blinked over their heads as they kissed, then loved each other on the on Selena's faded couch. Their sighs and moans were celebrated by the jolly carols that looped on her CD player.

At one point, shaking with exhaustion, hair mussed and tangled, Selena climbed from their nest and got a blanket. Ronnie pulled the girl into her embrace as soon as she returned. Her fingers went to Selena's spectacular breasts, teasing the nubs of her nipples to erection and flicking them lightly.

The couch was warm and – in spots – wet from their sweat. A small wastebasket beside the couch held a wad of saran wrap. Selena may not have been sophisticated, but she definitely had a flair for innovation.

It was late. The night had drifted into the early morning while they were inattentive. It was Christmas Day already.

"Was it what you were looking for?" Ronnie asked.

Selena shivered under Ronnie's touch, and groaned with pleasure. "This has been the best

Christmas ever," she said with a sigh, slumping into Ronnie's loose embrace. Her head rested on Ronnie's shoulder. Their breasts brushed companionably. "I've never had a good Christmas before," she confessed in a halting voice. "When I was young…"

Ronnie shushed her with a gentle finger leaned down for a kiss, chaste at first, but slowly deepening.

"Christmas isn't over yet," she murmured, coaxing Selena to lie on her back. Her hand trailed between Selena's breasts and down past her hand to play in the caramel curls that hid her cunt. They were sticky, and clung to Ronnie's fingers.

"Thank goodness!"

All in the Family

Sage Vivant

"I must really love you," Lee commented from the passenger's seat without turning to look at C.J.

"Oh?"

"Why else would I choose to spend Christmas in Cranston, Rhode Island?"

Now C.J. was the one who kept her gaze on the road before them.

"Because you need good stories to tell your office?"

"Ha! That, too." Lee smiled and finally turned to meet her lover's eyes.

"Cranston's not so bad," C.J. said, and instantly

cringed at the defensiveness in her voice.

"It ain't New York, sweetheart."

No, it certainly wasn't. But it was home, and it was where her mother was spending her first Christmas after the divorce. Lee understood that going to Cranston was C.J.'s only option this year and was gracious enough to volunteer to join her.

"So, do you think your mother will like me?" Lee teased.

"Who wouldn't like you?"

"An amazing number of men."

"Morons."

Lee turned heads of all genders and persuasions, so her modesty always came off as comedy. In jeans and a black turtleneck, she looked like a model for western wear. In high heels and a mini skirt, she was a poster child for raging hormones. Her smooth raven hair and deep, dark eyes were still a startling sight to C.J. – and they'd been dating for almost six months now. She had a regal kind of carriage that seemed to have gone out of vogue with the previous generation. If Jackie Onassis had been born to Lebanese parents, she would have looked like Lee.

C.J. had always been suspicious of dykes who fit Lee's visual profile. Make-up was artifice and fashion

was the ultimate sell-out in C.J.'s world. Lee's pitching arm made up for both, though, and her sense of humor transcended all manner of hair products. It didn't hurt that she had an ass that wouldn't quit, either.

"Is Elizabeth going to come?" Lee asked.

"No. She's going to spend Christmas with Dad. Thinks it's terrible that I'm abandoning him for the holidays."

"But it's okay that she's abandoning your mother."

"Apparently."

"Well, I can be like the missing sister, then." Lee concluded.

"Don't do that."

"Do what?"

"Mess with my head like that. You know this is hard enough for me."

"I'm sorry, honey. What did I say wrong?" Lee reached over to put a hand on C.J.'s thigh.

"You didn't say anything wrong, it's just that..."

Lee stroked her leg to comfort her as she struggled for words.

"I've never brought anybody home for Christmas before," she finally blurted.

"Are you saying that your mother doesn't know

you're gay?"

"That's what I'm saying." C.J. exhaled and waited for the barrage of recriminations.

"Yeah, neither does mine. It's just easier."

C.J.'s eyes widened. "You're kidding, right?"

"No, I'm not kidding!" They were both laughing now. "I don't have a husband because I'm a career gal!" She chortled and they howled at Lee's mother's naivete.

C.J. could have leaned over and kissed Lee for not giving her the how-can-you-call-yourself-a-lesbian-if-you-don't-shock-your-parents-with-your-sexuality bullshit. She'd feared that Lee, very much in possession of herself, would expect her to flaunt that brand of confidence in front of her mother. She'd anticipated Lee would insist on being called her girl-friend, sleeping in the same room, and facilitating some sort of dramatic denouement if the arrangement didn't sit well with C.J.'s mother. As the two of them drove toward Cranston, though, it was clear that Lee wasn't interested in forcing anything that didn't feel right. And that was precisely why C.J. adored her.

Cranston in the winter was a more monochro-

matic version of Cranston in the summer. Lawns that were varying shades of green in warmer months were uniformly dusted with frost in December, creating a somewhat institutional effect among neighborhoods. The sky stayed gray most of the season and the indiscernible contrast among it, the ground, and the colorless homes made the indoors an welcome escape for both body and soul.

Not that Cranston was all that different from any other southern New England town, but to C.J., it always seemed just a little more drab, a little more depressing than anywhere else. Yet, she didn't dislike the place. She just had no fondness for it, childhood notwithstanding.

"You're not going to take me on a tour and point out where you went to high school, are you?" Lee asked, as they wove their way down the wide concourse of Reservoir Avenue.

"Hell, no. I won't even show you Twin Oaks, where people wait for hours to get the best baked stuffed shrimp you ever had."

"Well, that's a relief. I'm sure you were an adorable high schooler but I prefer the adult you've become."

As they turned into Carnation Drive that

Christmas Eve afternoon, the sun had begun its descent and colorful lights already burned in the great pine shrubbery that flanked the front of the house. A large, excessively animated snowman oblivious to the chips and discolorations in his painted scarf and carrot nose waved at them.

"How festive," Lee commented, smiling indulgently at C.J. When C.J. rolled her eyes with embarrassment, Lee took her hand. "It's nice, honey. Really. Everything's going to be fine. It'll be sweet to have a real Christmas out here in the burbs."

C.J. fought tears. "Thanks." She kissed her forehead. "I needed that."

"I'm here for you. I would never want to make this trip more difficult for you than it needs to be. Let's go meet your mother and give her hell about that snowman."

The thin film of old snow crunched under their feet as they made their way up the driveway to the side door of the 60's ranch style home. At the bottom of the short flight of stairs, the screen door flung open and a plump, pretty woman smiled a greeting. It took C.J. a few seconds to recognize the woman as her mother.

The svelte blonde who'd been her father's highly

prized arm ornament still lurked beneath the surface of this person but she was a distant memory. As everybody hugged and introductions were made, C.J. could barely concentrate on her words – she'd never seen her mother look so…radiant. The extra pounds softened her and took away that eager edge she'd always had.

"Lee, this is my mother, Marie. Mom, this is Lee," C.J. said nodding at each woman as she introduced her.

"Lee, it's so wonderful to meet you," her mother said with typical graciousness as she embraced her visitor. Lee smiled and hugged back with equal warmth.

"Mom, I have to tell you. You look fantastic!" C.J. said.

Her mother blushed and smiled the smile of someone who acknowledges the truth in a compliment she receives. "Thank you, honey. Divorce seems to agree with me."

"Oh, I'd know that face anywhere! You must be Carolyn Jean!" boomed a voice from the kitchen. As everyone turned to trace it, a voluptuous, light-skinned black woman floated toward them.

"This is my friend, Beverly," Marie explained. "She

lives two doors down, in the old Petricone house."

C.J. hadn't expected to encounter anybody else but took an immediate liking to Beverly, whose expansive, easy movements and throaty laugh made her feel like an old friend. "Nice to meet you," she dutifully replied, almost losing her balance when the big woman threw her arms around her.

"Beverly is alone this Christmas, so I thought it might be nice to include her in our celebrations," Marie said.

"Of course. The more the merrier," C.J. heard herself say as she smiled at Beverly.

"What could be better than an all-girl Christmas?" Lee remarked.

Beverly roared. "I can't argue with you there. There's always so much more work to be done when men are around at Christmas, have you noticed?"

"Have you ever been married?" C.J. asked, curious about the woman's past and wondering about the circumstances that resulted in her being alone for the holidays.

Beverly waved a dismissive hand and grinned mischievously. "I don't believe in marriage, sweetheart. I only believe in love." She winked and Marie giggled.

"Beverly is a free spirit," she explained, smiling a

proud smile at her friend. "Like you, C.J.!"

C.J. and Lee exchanged a brief but meaningful glance, careful not to hold it long enough to be observed by Marie and Beverly. "What do you mean, Mom?" C.J. finally asked.

"Oh, you know. Independent. Non-traditional. Now who wants egg nog?" Her eyes glistened with excitement.

Throughout dinner, Beverly inquired with genuine interest about C.J. and Lee —without ever making specific reference to their personal partnership. She asked lots of questions but was never intrusive. Consequently, C.J. tiptoed around questions she most wanted to pose to the woman. Questions like "why are you here at our Christmas?" and "are you a friend of Dorothy's?" Beverly helped Marie in the kitchen as if she'd had occasion to do so in the past yet she was equally comfortable sitting back and being served.

"Isn't this just the loveliest Christmas Eve?" Beverly sighed as she sat back in her chair at the end of the feast Marie had prepared. "You girls will look back on this and appreciate it more later than you do now. Time spent with women is so rare. So special." She stared wistfully at some distant point beyond

Lee's head.

"It's a shame, though, that Elizabeth couldn't be here," Lee added.

"Oh, my dear, that's why we're so delighted that you could be here. C.J. cares about you so much, it's almost like having her sister here."

"That's sweet," Lee said, unleashing the megawatt smile.

C.J. paced the shag carpeting of her old bedroom, waiting for Lee to sneak out of Elizabeth's room and into hers. As the clock on the nightstand ticked, C.J.'s mind raced. The knock on the door made her jump.

"Jeez, I thought you'd never get here," she hissed, pulling Lee by the arm into her bedroom.

"What's with you?" Lee asked, stepping back from her lover to allow C.J. to get a good look at her luxurious black silk pajamas. C.J. shot a lopsided grin at her, grateful for the brief diversion.

"You look fabulous."

Lee's nipples poked at the liquid drape of the fabric. The ends of her long dark hair brushed the silk in small, sensuous sweeps. "Thanks. And you look adorable," she purred, hands on hips, as she nodded toward C.J.'s Laura Ashley gown. "Now why are you

so worked up?"

"What do you think of Beverly?"

"Can we get in bed and have this discussion?"

C.J. tilted her head to consider. "Okay."

They crawled under the covers. C.J. sat up, leaning her back against the creaky wooden headboard. Lee curled up in her lap, with the blanket drawn up close to her face.

"So, what do you think?" C.J. persisted.

"Of Beverly?"

"Yes, of Beverly! That's who we're talking about!"

"She seems very charming. I can see why your mother would find her a comfort at this point in her life."

"What do you mean, a 'comfort'?"

Lee moved her head and supported herself on one elbow as she looked up at C.J. "Comfort. As in friend. People who can relax and enjoy each other. Like we used to." She stuck her tongue out at C.J.

C.J. stroked the brunette's well-conditioned head absently and continued. "Do you think they're just friends?"

"I don't know your mother well enough to assume anything else."

"Well, my mother never had any real friends when

I was growing up. She had neighbors, she had acquaintances, she even had contacts, but she never had friends."

"That's sad," Lee said, nestling back into C.J.'s lap. "Why was that?"

"I think my father frowned on it. I don't know for sure. It's just that I've only seen my mother in relationship, not necessarily friendship."

Lee played with the buttons at C.J.'s chest, unbuttoning them so surreptitiously that C.J. didn't notice until she felt a draft at her neck. Even then, she was too absorbed in her thoughts to stop Lee.

"Are you trying to say you think your mother might be in a – " she paused to lower her voice and look C.J. directly in the eye, "—lesbian relationship?" She kept her eyebrows in a permanently shocked arch.

"Don't make fun of me. Yes, that's exactly what I think."

"Mmmm. That would be completely unacceptable, wouldn't it?" Lee went on, slipping a hand into C.J.'s nightgown, traveling slowly until her fingertips reached a nipple. "I mean, the things I've heard that lesbians do, well, it's shocking."

She rolled C.J.'s nipple between her thumb and

forefinger, delicately, just the way C.J. liked it. Just intense enough to make her moan.

"They play with each other's bodies but they call it making love. Can you imagine?"

"Lee, come on…"

Lee brought her face to the now swollen nipple and flicked her tongue at it. "I mean, by day, they seem like friends, but at night, they're positively demonic. Licking," she licked, "and sucking," she sucked, "like animals."

C.J.'s ample breast filled Lee's palm as her nipple expanded in the warmth of her mouth. C.J. ran her fingers through Lee's beautiful hair, silently encouraging her to continue. The heat from her solar plexus rose up until both of them felt it. Lee continued sucking but moved her hand down along C.J.'s thigh, over the soft flannel, until her arm was outstretched. Then, she deftly pleated the remainder of the nightgown in her palm so that C.J.'s shins were exposed. She disengaged from the pink nipple long enough to speak.

"The problem with lesbians," Lee said quietly as she brought the handful of nightgown up to C.J.'s steamy blonde muff, "is their mouths. It's bad enough that they never stop talking, but I've heard they actually kiss each other down there."

The cool silk of Lee's pajamas melded with the smoothness of her hair as her face approached C.J.'s pussy. Her lips skimmed the freshly showered pelt that was already scented with the heady aroma of cunt. C.J. threw back the covers so she could watch Lee between her legs. The sight of that dark head burrowing into her most intimate crevices always pushed her erotic buttons. She spread her legs to give Lee better access and surrendered to the sophisticated woman's finesse.

Lee's tongue slowly followed the curves of her labia, sometimes dawdling to savor the juices along the way. She waited until C.J. was close to bursting before she applied her expert tongue to her aching clit. Once there, the assault was fast and furious, a combination of finger frigging and tonguing that sent C.J. spiraling into oblivion. She held on to the headboard for support and forced her shouts to stay in her throat.

Moments passed. C.J.'s breathing returned to normal and Lee returned the nightgown to its horizontal position before cuddling in her lap once again.

"Shit," C.J. hissed.

"What's wrong?"

"I'll bet the damn headboard made enough noise

to tell everybody what we were up to."

Lee chuckled. "Have I ever told you you're cute when you're neurotic?" She kissed the tip of her nose. "They're still down in the kitchen. I can hear their voices."

"See what I mean? Why is Beverly still here at this hour? Is she spending the night?"

"C.J., really, all kidding aside, why does this woman bother you so much?"

"It's not Beverly that bothers me. I just need to know if she and my mother are together."

"You mean like we are."

"Yes!"

"What do your instincts tell you?"

"That they are and that this Christmas thing is my mother's way of breaking it to me gently."

"And would that upset you?"

"No, but don't you see what it means for me? I'll be forced to tell her about me. About us."

"Well, you won't be forced to do that, sweetie. And won't it be a lot easier if she shares your enthusiasm for women?"

C.J. shut her eyes. "I never thought I'd be having this conversation. I hate this."

"Go to sleep. It'll be clearer in the morning." Lee

kissed her softly on the lips and they spooned until C.J. gradually drifted off to sleep.

The morning did bring clarity. When C.J. opened her eyes, she heard Beverly's laugh floating up from the kitchen.

"Do you hear that?" She whispered to Lee. "She must have spent the night here!"

Lee groaned. "Maybe she did. So what?"

"I've decided I'm going to tell my mother about us," C.J. announced.

Lee opened one eye and focused it on her single-minded girlfriend. "Before breakfast?"

"Not necessarily. I'm going to wait until I feel the time is right and then I'll just come out with it. Then, she'll feel more comfortable telling me about Beverly."

"All right. Whatever you say. I'll be there to say whatever you need me to say." She rolled over. C.J. smiled and got out of bed, happy to have reached a conclusion and eager to implement her plan.

"Hey!" She exclaimed, halfway to the bathroom. "You've gotta get back to your room!" She returned to the bed and tore the covers off her slumbering lover, who grumbled in a steady stream of expletives

at being exposed to the chilly winter morning. "Until I make my announcement, you and I are just friends. So get back to your room, young lady!"

The Christmas dinner table was resplendent. A modestly plump, golden turkey graced the center of the lace-covered table, and in cream-colored Lenox serving pieces sat homemade cranberry sauce, brilliant butternut squash, green beans almondine, and browned potato slices, just waiting for healthy slabs of butter. Wine from one of Rhode Island's vineyards filled each wine glass. The prolonged heat generated by the constant cooking had fogged the windows, which fought freezing temperatures from their other side. A fire crackled in the fireplace.

"I'm so grateful for this day," Marie said, eyes filled with tears. "I love each and every one of you. It means so much to me that you're all here."

Beverly reached over and grasped her hand. Wordlessly, she squeezed it.

The gesture was the sign C.J. had been waiting for. She reached for Lee's hand and squeezed it the same affectionate way. Lee said nothing, looking expectantly from C.J. to Marie to Beverly.

"And it means so much to me that you and

Beverly have found each other," C.J. said, inhaling deeply to keep her voice even.

"She's been a godsend," Marie said.

"Just like Lee has been for me," C.J. replied. "I'm so happy for you, Mom. Many women never find love again after they divorce but you and Beverly seem to have been destined for each other."

Nobody said anything but all eyes were on C.J. The silence inspired her to continue.

"I'm not just glad that you've found someone special, Mom. I'm excited because now I can tell you how much Lee means to me without having to pretend that she's just a friend. Now that you have Beverly, you know what it's like to share your life with a woman who understands and accepts you. I've been wanting to tell you about me for years, but now that I'm with Lee and can see that you and Beverly are in love, it feels really good to tell you I'm a lesbian."

Marie's eyebrows shot upward. Beverly's followed suit. The silence was deafening.

A ball of molten lava ignited in the pit of C.J.'s stomach and swept up toward her face. She wanted to crawl under the table and flee from the house simultaneously. Mostly, though, she wanted to erase every word she'd uttered in the past ninety seconds.

She could not find her voice.

"You think we're lesbians?" Beverly asked, her eyes perfect circles of incredulity.

"Well, yes," C.J. squawked uncertainly.

The two older women stared at each other for several seconds before they burst out laughing. The longer they laughed, the louder their shrieks became. Tears rolled down their cheeks as their round bellies shook with amusement.

"Oh, sweetheart," Marie finally said. "I'm sorry to disappoint you, but Beverly is not my girlfriend. At least, not in the biblical sense."

Another gale of giggles.

Lee fought a smile but kept a reasonably stoic composure as she bit her lip. C.J. had no idea what to say. She was mortified beyond words.

Marie suddenly seemed to absorb the impact of her daughter's confession and made a conscious effort to stop laughing. With genuine concern, she gazed straight into her daughter's eyes. "But I've always known you were gay, honey. No boyfriends in eighteen years and an avid interest in softball – I got the message a long time ago."

Now it was Lee who broke into uncontrollable laughter. She got up and wrapped her arms around

C.J.'s neck as she kissed the top of her head.

"You'll have to forgive our C.J.," Lee said, pressing her cheek against hers. "She never dreamed she'd be a homo for Christmas."

The three women roared in unison and laughed until even C.J. had to join them.

The Snow Queen

Lori Selke

Erika Frost's holiday soirees were legendary. The wealthy widow threw the poshest of all parties on the eve of the Winter Solstice every year, inviting not only the cream of the socialite crop, but notable artists, writers, and other cultural figures -- and also the loveliest ladies of all stripes, for Ms. Frost was well-known to have taken a turn for the sapphic in her twilight years.

Frost's current paramour was rumored to be a bit of a guttersnipe named Kay. Where she had come from, how the two had met, was entirely unclear, and therefore ripe for speculation. Almost no-one had

met the mysterious Kay, although she was said to be a handsome, if unpolished, butch lass. For months now, Frost had hardly been seen in public, assumed to be cuddled up under warm sheets with her newest acquisition. So for Frost's friends and acquaintances, the Winter Party would serve as Kay's debut into the rarefied circles her lover preferred to move in. No doubt Frost had been cultivating Kay's social image and skills, preparing her lover and protégé for her entrance into society. All of Frost's guests looked forward to witnessing the unveiling of Erika Frost's newest companion.

Erika Frost had been beautiful when she was young, a blonde Scandinavian queen. Now that she was older, she had retained the proud, regal bearing, but her hair had turned white and the lines in her face, while not unattractive, were severe. That severity was offset by the manner of her dress, which was never less than sumptuous. She favored furs, and colors that complemented her pale skin, deep blues and silver. She was never ostentatious, however, always within the bounds of taste.

Gerda had no idea how she was going to swing an invitation to the Winter Party, but she knew she had

to find a way.

Kay and Gerda had been lovers, not so long ago. Gerda had thought they were happy. But Kay had been haunted by an inner darkness that no amount of love from Gerda could heal.

"It's too hard," Kay said one night, as they lay together, naked, in bed. "There's no place for me in this world."

"Nonsense," Gerda said. "Your place is here, with me." She pulled the covers up to her shoulders to cover the both of them.

Kay sighed. "That only lasts while we're here, together. But when I leave this apartment, when I walk down the street...you've seen how people look at me. I'm so tired, Gerda. Tired of the checkout girls in the grocery store flinching when they accidentally brush my hand. Tired of threatened men picking fights with me when I walk down the sidewalk."

"Maybe you should make friends with some other butch women," Gerda suggested. "I'm sure you're not the only one."

"It wouldn't make a difference," Kay said.

And then Kay had met Erika Frost.

Ms. Frost had swept into the gym where Kay worked as a massage therapist. She disrobed without

a blink, threw herself down on the table, and demanded that Kay attend to her that instant. Kay was used to the bossiness of the gym's posh patrons. But when her fingers touched Erika's cold flesh, something electric happened. It wasn't right to hit on clients, she knew, so she ignored it and merely worked her magic with Erika's body. But when Erika tucked her card into the waistband of Kay's pants, she also knew that what she did outside the gym was no-one's business.

Afterward, Kay was embarrassed to admit that she hadn't realized who Erika Frost was. But Erika had been charmed by her ignorance.

To Gerda, it was as if Kay had simply disappeared. Kay had left her with no warning, just a note: "It's not that I don't love you. But Erika has promised to take care of me, to shield me from the world. She's what I need. Life is too hard when you're poor and queer. One of those things is beyond my control. But the other isn't anymore. Goodbye."

Gerda had cried hot tears onto the paper, blurring Kay's cramped, tiny handwriting.

Gerda knew that she had to see Kay again, one last time. She had to see it in Kay's eyes, that she was mak-

ing the choice freely and with her whole heart. Only then would she be able to let her lover go.

Gerda had taken a temporary administrative job at a catering firm for the holidays. Luckily for her, it was the same catering firm that Erika Frost chose to hire for her Winter Party. Gerda was not supposed to be on the staff for that event -- all her work was in the office, not on site. But she befriended one of the servers, a redheaded girl named Claudia, and Claudia thought it was the height of fun to try and sneak Gerda in through the back door.

The caterers jokingly referred to themselves as "The Crows," for they all work black uniforms, the better to blend into the background. They were the stagehands of the great events they attended; their labor was necessary, but it was part of the job not to be noticed. Even when visible, they were ignored by the guests. Although Gerda could not understand how anyone would fail to notice Claudia -- her hair is firetruck red.

Claudia lent her a set of clothes that fit well enough. The uniform resembled a tuxedo, but it was-n't really. Claudia thought it was funny that the cater-ers might be the best-dressed people at the party. "Rich people can wear whatever they like." she said,

smoothing her flaming red hair back with pomade as she prepared for the big event. "We're the ones who have to uphold the social order of things." she adjusted Gerda's lapels. "Nobody will know you don't belong with us," she said. "Don't worry! We sneak people in like this all the time." She leaned over to whisper in Gerda's ear. "Bring your party clothes, you can change in the bathroom. Nobody will know you aren't one of the posh set. Frost herself hardly knows half the people she invites."

Kay was nervous, pacing the length of the Erika's bedroom. Not her bedroom. She had her own room, smaller, elsewhere in the house. But at this moment, it was important to be near her lover.

"Your friends are going to hate me," Kay said.

"Nonsense." Erika was enthroned behind her vanity mirror, painstakingly working her way through a complex beauty regimen. "They will adore you. Your coarseness, especially. It will give them an illicit thrill." She turned and smiled at Kay. "You must trust me. After all, I know them better than you do. I've known them for years."

Kay picked up the tuxedo jacket that had been laid out over the blankets, held it at arm's length. "They'll

know it's just a costume. That I'm a fake."

"They won't mind. They're all fakes themselves." Erika stood and came up behind Kay wrapping her pale arms around her waist. "I know what will calm you down," she said. She unbuttoned the fly of Kay's pants and slipped her hands inside. Then, grabbing the material, she spun Kay around in her arms. She took a step back, releasing her lover; Kay had to reach down to keep her pants from sliding to the floor. Then Erika lifted her ivory slip above her waist, and bunched it in her hand. She took Kay's hand and slipped it between her legs.

Kay knew what to do. She found Erika's clit, already moist with her juices, and tickled it until her lover squirmed. "I love your hands," Erika breathed in her ear. "They're the sexiest part of your body." She parted her thighs to allow Kay to slip her fingers in deeper. "Not to neglect the rest of you," Erika added, trailing a finger along Kay's neck, down into the open collar of her shirt. She kissed Kay behind the ear, her breath hot against Kay's skin. She spoke secret words of desire as Kay worked her tender parts, causing them to flush with pleasure.

At last Erika pulled away and lay herself on the bed. "You don't want anything else but this, do you?"

she said with a smile, stroking her open thighs, her wet cunt. Kay fell to her knees to taste the nectar gathering in Erika's folds. "I'm all you need," Erika crowed with pleasure as Kay's tongue brought her to climax.

And it was true, all Kay's troubles were forgotten for the moment.

Erika Frost's party was always held at her home; she threw open all three floors of her city house for the occasion. She hired only the best caterers and waitstaff for the night. Oysters and champagne, caviar and vodka, aquavit and gravlax -- the tables were laden as if this would be the last good food before the long, dark winter set in in earnest.

Gerda was too nervous to eat. She sipped at a flute full of icy-cold champagne, pale as her eyes.

Surely someone would notice that she was an uninvited guest.

She'd changed in the glorious bathroom on the lowest level of the house. Gerda couldn't believe how large it was. Soaps shaped like roses in a dish by each sink. Ivory towels, softer than any she'd ever touched. Silvery fixtures, and a mirror that ran from counter to ceiling. In it, Gerda could see herself in her dark

green party dress, surely out of style by at least a few years. She tugged at the skirt and the straps, checked her stockings for runs, fit her feet into the low-heeled dancing shoes she'd brought, comber her blonde hair until it shone like honey and then fastened it at the neck with a rhinestone clasp. At least the color of the dress brought out the pink in her cheeks, she thought, examining her image with a critical eye. With luck, I won't be so out of place that someone notices and kicks me out before I can talk to Kay. I can just fade into the background. I'll be one with the wallpaper.

The whole house was hung with mirrors, ablaze now with the light of countless candles. Gerda tried not to look at her reflection, her every flaw magnified and repeated, surely, for all to see. This drab little sparrow she was, lost among peacocks. Kay would be one of them, now. Perhaps she wouldn't even recognize her lover when the time came, so transformed would she be by the touch of Erika Frost and her rarefied world.

Gerda plucked a flute of champagne from a passing tray; the caterer winked at her, and she showed him a nervous smile before draining it. Before she

could set it down, however, it was whisked out of her hand. Gerda heard a giggle behind her, and turned to see who it was.

It was Claudia. "You don't want to be getting drunk tonight," she said, waving a scolding finger.

"It's only my first glass."

"I'm only teasing," her friend said. She stood back and admired Gerda's evergreen gown. "You look absolutely lovely," she said, and leaned in to murmur in her ear, "Nobody will ever guess." Before she stepped back, Gerda found her neck encircled by a chain, hung with a jeweled, heart-shaped locket. "It was my grandmother's," Claudia said. "But you can borrow it for tonight. Don't worry," she added, "It's garnet, not ruby."

The locket winked crimson in her cleavage. Gerda fingered it with wonder. "It's too lovely," she said. "I couldn't possibly."

"Nonsense." Claudia said, kissing Gerda on the cheek before whirling away with her tray, too fast for Gerda to catch. "Have fun at the ball, Cinderella," she called in a high voice.

Erika Frost straightened Kay's lapels, smoothed her hair back with a slick gel. Her hands were pale and

practiced. The tuxedo Kay was wearing had been expertly fitted to her body just a week before. "You look every inch the gentleman," Erika said. "Now zip me up." She turned her back to Kay. "It's so nice to have a butch around the house again," she said as Kay's hands pulled the fabric of her tight silver dress together. When Kay was finished, Erika turned and gave her a passionate kiss. "Tonight, you are a swan," she said. "My elegant, perfect paramour. Everyone will be jealous. They'll wonder what you do for me that they can't. Let them wonder." She laughed and stroked Kay's cheek. "Let their imaginations run wild. You'll be my squire, my escort. I will show you things you thought you'd never see. I'll take you to Paris, to London, to Rome, to Milan. Though I must say I'm not fond of Italy. It's too hot."

Kay's hands lingered on Erika's hips. The older woman tucked a silver cigarette case into the chest pocket of Kay's jacket. Her fingertips brushed Kay's nipple as it withdrew. Kay stiffened. "Oh, I forgot," Erika teased. "You like to be stone. Well, from this night on, you'll be a stone, alright -- a flawless diamond in my crown." She took Kay's hand in hers. "Come. Let's go greet our guests."

Erika Frost knew how to make an appearance.

When the pair appeared at the head of the wide staircase that led into the main hallway, a hush fell over the assembled guests. People jockeyed for a vantage point from which to view Erika and her paramour. Even Gerda turned to look, and saw Kay standing at the elbow of her new lover, looking as handsome as she'd ever seen her. Oh, she was truly transformed, no longer the awkward but ardent Kay she'd known. Her step was smooth, her face a mask of cool indifference. Her fire was banked, Gerda thought with dismay. Is this what Erika wanted?

The pair descended the steps with measured grace, and when they reached the bottom, the whole party crowded around them, chattering all at once, a sudden roar. Gerda slipped into the kitchen to watch her new friends set out the trays of food they had so artfully prepared. Then she drifted toward the emptied front room and its roaring fireplace. She rubbed her bare shoulders against the sudden chill.

When she was warm again, she decided to dare herself and explore the rest of the house. For it was true that Erika Frost owned a mansion full of surprises. Gerda had never seen a place with so many rooms. In the front room, not only was there a fire-

place, but also a grand piano; Gerda wondered if anyone ever played it. In the study, a huge antique wood desk had been pushed against the wall to accommodate the guests. In the foyer, a beautiful crystal chandelier glittered with the light of the candelabras in the corner. From the center crystal, a large sprig of mistletoe hung. Gerda turned around and around underneath the chandelier, looking up into its mirrored lights, her skirt flaring out around her. She pretended she was outside, beneath a sky full of stars, and she twirled until she was dizzy.

Familiar hands caught her shoulders just as she was afraid she might fall. She laughed. "Claudia? You were right, the champagne went right to my head..." Gerda turned around and found herself in the circle of Kay's arms. Her breath caught in her throat. "Oh."

"How did you get here?" Kay asked, voice steady, betraying no emotion at all. "Erika couldn't have invited you. She doesn't even know you, does she?"

Gerda felt her cheeks burning.

"Are you someone's date, then? Who brought you?" Kay looked over her shoulder. "Why aren't you with them? Why are you alone?"

Gerda giggled despite herself. "Alone, under the mistletoe. So sad."

"Did they ditch you?" Now Kay sounded stern. "I'll call a cab. I'll get you home safe. Don't worry."

"No!" Gerda clutched at Kay's arm. "I don't want to leave." She couldn't look Kay in the eye any more, so she ducked her head and whispered into her chest, "I came to see you."

Kay stood still; Gerda rubbed her face against her shoulder. "I know it was foolish of me," she said. "I just wanted to see if you were happy. I wanted to let you know..." Gerda found tears springing to her eyes, and willed them to stay trapped behind her lashes. "It's OK if you want to be with her instead of me. If you're happy. But you can't just disappear like you did, it's not right." The words were a flood. "What am I supposed to tell our friends? You should call them, they miss you, I miss you...this isn't coming out right." She pushed Kay away. "I came to say goodbye. You have to say goodbye. You can't just sneak away in the night. I deserve better than that. I haven't come to win you back, she can have you if that's how you want it. I don't need an explanation, I certainly don't need you, but I do need..."

Kay wasn't listening; she was staring at the charm around Gerda's neck. "I haven't seen that before. It's new."

She reached a hand out to touch it. Gerda resisted clasping Kay's hand in hers. "It's a gift," she said, "from a friend."

"A girlfriend?" Gerda shook her head. "It's lovely," Kay said. She looked up from the pendant and met Gerda's eyes. Then, before she knew it, they were kissing, a kiss that made her flush from her cheeks, down her neck and chest, sending a thrill into her fingers and toes. She didn't know what to do with her hands, so she kept them rigid at her sides. Kay took one in hers and squeezed it and wouldn't let go.

"I've missed you," was all Kay said when the kiss was done.

"Kay, someone must have seen us; what will you say?"

Kay smiled. "I'll say I saw a lovely lady beneath the mistletoe who deserved a kiss." She pulled at Gerda's hand. "Come on. Have you seen the bathroom?"

Gerda laughed. "Actually, I have." But she allowed herself to be tugged along.

When they got inside, Kay locked the door behind them. She picked Gerda up and sat her on the counter. Then she stepped between Gerda's knees and leaned in for another kiss, slower this time.

"What about Erika?" Gerda asked as Kay pushed the skirt of her dress up around her waist and began stroking her thighs.

"She's not here," Kay said.

"She'll find out."

Kay shrugged and kissed Gerda again. This time Gerda pushed her away.

"I need to know," Gerda said. "What this means. Is this ex sex? A little holiday fling? Are you drunk? Am I?"

Kay's voice was low and husky when she replied. "I don't know," she said. "All I know is that you're as beautiful as the first day I met you, and that I've been cold, so cold, all these weeks in Erika's house. I turn all the thermostats up, every day a half-degree higher. I wear cashmere sweaters that she buys for me. I build a fire in the fireplace, stoke it till it blazes. Nothing helps. Every morning, I check my fingertips for frostbite, look in the mirror to see if my lips have turned blue. And when I saw you, dancing underneath the chandelier, you were burning, you looked like a flame."

Gerda looked down at her dress. "A green flame?"

Kay smiled. "Yes. With a fiery red heart."

Gerda touched her cheek. "This is the first time

I've seen you smile all night."

"It's been so long since I've smiled, I was afraid my face might crack." Kay stepped back and put her hands on Gerda's knees, pushing them open. "Take off your panties."

Gerda lifted her butt off the cold counter and slid her panties down her thighs. Red panties, silky and skimpy. Kay gathered them in one hand and pulled them away, tossing them behind her. She put her hands on Gerda's breasts. Gerda smiled as they kissed again, as Kay's fingers found her nipples, hard from rubbing all night against the lacy fabric of her bra.

When Kay's mouth moved away from Gerda's lips and down, toward her neck, the exposed surface of her breasts, Gerda whispered, "Don't speak. Just kiss me. I'll warm you." She placed Kay's hand between her thighs, where her wetness was already obvious. "Put your hands there, and you'll never need gloves." Kay started to laugh, but Gerda smothered her mouth with kisses, moving her hips, urging Kay's hand to explore deeper, deeper. She gasped when Kay found her clit, and clinched her legs around Kay's waist. Her cunt opened up to take two fingers, then three, then four. Then Kay was curling her wrist, pressing against Gerda's most tender spot, her thumb on Gerda's clit,

jerking her off ferociously, and Gerda was falling against her shoulder, muffling her cries in Kay's lapels, crying and shrieking and coming. And it wasn't enough, Kay wouldn't stop, Gerda didn't want her to stop. Kay fell to her knees, her head buried under layers of green chiffon, as Gerda braced her heels against the counter and let Kay lap up her abundant juices. Now their lovemaking wasn't so frantic, though it steamed up the bathroom mirrors and glazed Kay's face with moisture. Nor was it tender, not with Gerda clawing at Kay's shoulders, tugging at her hair, clenching her thighs as she flooded Kay's mouth with her come.

Finally, Gerda pulled Kay's face back up to hers, and with a smile, she licked her cheek and chin like a cat with cream. She locked her ankles behind Kay's waist and rested her head against Kay's shoulder. After she caught her breath, she looked up at her lover. "Erika," she said. "She doesn't touch you, does she?" She let her fingers stroke the front of Kay's pants with a feather touch.

Kay turned her head away. "She likes butches," she said.

"When did you become stone?" Gerda asked. Kay only shrugged. Delicately, Gerda unzipped the fly of

her trousers, reached into her boxers, and put her palm flat against Kay's mons. Kay let a small groan escape as she buried her face in Gerda's hair. "Don't speak," Gerda repeated as her hand moved lower. "Don't speak unless you want me to stop."

Gerda's fingers stroked Kay's clit with a practice born of familiarity; she was careful to do no more. It was enough to make Kay's knees buckle, and to bring tears to her eyes. It was enough to make her howl with a release she hadn't known she needed. Kay broke out in a sweat, and began to shiver. Gerda wrapped her arms and legs around her lover and kissed her again and again, on her lips, on her neck, on her hands and chest and forehead. She stroked the blush that rose on Kay's cheeks as they rocked together, as the ice fell away from Kay's heart.

At last they pulled apart, sweaty and disheveled.

"I don't know what comes next," Kay admitted.

Gerda combed her fingers through Kay's hair. "We get cleaned up," she said simply. "We go back to the party. You meet Erika's friends, you play her beau, and you see how it feels. I go back home, and you stay here." She paused, playing with a lock of hair behind Kay's ear. "And then..."

"And then we meet for breakfast. Tomorrow. I'll

slip out before Erika gets up. We can talk then."

Gerda hesitated, then nodded. "We'll see where we are then. You'll tell me what you've learned while you've been away. And you can tell me if you want to come back." Kay started to speak, but Gerda put a finger to her lips. "Don't tell me now. I'd believe anything you said to me. Tell me tomorrow." She removed the finger and kissed her lover one last time. "Thank you for tonight. Even if we decide, tomorrow, to go our separate ways, this was the best Christmas present anyone ever gave me."

Then Gerda slipped off the counter, straightened her dress, touched up her makeup, and left the party for her own warm bed.

Frozen

Andrea Dale

Becca wanted to get a tree on December first.

I tried to talk her out of it, but she was having none of that. Her father had a tree farm in the mountains, she said, and when she was a kid she'd always been the one to pick out their family tree. Now, he continued to give her one for free—and she wanted to beat the rush and get the absolute best one possible.

I, on the other hand, wasn't even sure if I'd still be around on the twenty-fifth. I went with her, because I couldn't resist that adorable uptilted nose and the dimple on her left cheek, but I made no promises otherwise.

It had snowed on and off since early November, and the world was white and eerily silent except for the sound of our boots crunching through the frozen cover. Beneath the tall pines, all lined up stately and proud, the snow cover was thinner, and occasionally I scuffed up enough to see the brown needles and dirt beneath.

"It's not normal," I said for the what seemed like the hundredth time. "This white stuff falling from the sky at regular intervals. You should be able to visit winter, and then go home."

Becca laughed and kissed my cheek, her lips warm against the flesh that was reddened by the cold. "Oh, you California girl, you," she said. "How can it be the holidays without snow?"

It was a familiar argument, with no underlying malice or anger. We were just from very different places, and teased each other about it.

A few moments later I realized we'd left the carefully planted rows of trees and had headed on a slight incline, through birches and firs and other trees I couldn't quite identify, all more jumbled together. I pointed out our misdirection.

"Oh, I know," she said. "We never get our own tree from the farm proper. My dad owns acres and

acres here, and it's our tradition that we get our tree from farther back."

I bit back a sigh, wistfully imagining a steaming cup of hot chocolate laced with crème de menthe. Shoving my hands in my pockets, I followed Becca deeper into the wintry woods.

It wasn't much of a problem following her, actually, because I could focus on her sweet ass, contained in a pair of tight jeans (with silk long underwear beneath, I happened to know, having been involved in making it difficult for her to keep them on earlier today). Right now, there wasn't anything I wanted more to be in a nice warm bed with her, my hands cupping that tight bottom as I buried my head between her thighs and made her wail as she came. I loved the sweet taste of her slippery folds, like cinnamon, and how they turned so dark when she was aroused, fiery red like the rest of her. Afterwards I'd kiss away the orgasmic flush from her delicate breasts, only to be unable to resist taking one of her pert nipples in my mouth, and then we'd be starting all over again...

The trees thinned as we walked, and Becca paused to let me catch up, slipping her hand into mine. The intimacy of the action, despite the layers of knitted

wool between our fingers, touched me. We'd been dating for seven months now, living together for two-and-a-half, and yet I was still surprised by the tenderness. I felt guilty, too—after Lindy's death, I didn't think I'd ever open up to anyone like that again.

I hadn't intended to move in with Becca, exactly, but the lease ran out on the apartment I was subletting and Becca had a spare room. Not that I ever slept in it, mind you—we set up the other room as a studio for me and an office for her.

I'd fled California when Lindy died after four years of living and loving together. I immersed myself in grad school in Minneapolis, as different a place as I could find, and that's where I'd met Becca.

We'd started out talking about architecture, and tumbled into bed not long after that. When she was through stunning me with her energy and inventiveness and I'd caught my breath, we went right back to talking…and then right back into screwing again.

I never stopped missing Lindy, but when I was tangled and sweaty with Becca, the pain lessened. She had that effect on me—perhaps because she was so unreserved, so delightfully free.

I made Becca no promises, knowing she deserved

more than I could give her. But when I tried to tell her that, Becca would shake her head, brushing her silken red hair across my face, and tell me that our time together was all that mattered.

"We're only given a certain amount of time on this earth," she'd say. "Use every moment wisely, to the greatest extent that you can."

I was afraid Becca would fall in love with me, and I'd have to leave. But right now, I was trying to live in the moment. Even if it was a very chilly one.

We came to a clearing, a circle of trees with the snow untouched in the center.

"So beautiful," Becca breathed. "So pure."

"It is pretty," I agreed reluctantly. "Pristine. Like we're the first people to come here."

She kissed me again, this time on the lips, her tongue caressing. Then she pulled back, and I saw a mischievous glint in her eyes.

"Snow angels!" she shouted, her voice startling a cardinal into a flutter of crimson. She grabbed my hand again and dragged me into the center of the clearing. Flinging herself down on her back, she waved her arms and legs frantically.

"Are you having a seizure?" I asked dubiously.

She laughed as she sat up. Carefully she stood and

took a big step away from where she'd been lying. I could see the outline of her form in the snow, and suddenly I understood what she'd meant.

"You try it," she said, dusting the snow from her legs.

"I don't know," I said. "Looks cold. And wet. How come snow's never wet in the movies? You see people walking with the snow falling around them, sticking to their heads and shoulders, but when they go inside, they're dry, and there're no puddles on the floor..."

Becca laughed again and pushed me, not quite hard enough to make me fall down. Suddenly catching her playful mood, I nudged her back. She shoved me again, and I started to lose my balance. I grabbed her as I tipped, and she landed atop me, face inches from mine.

Now neither of us were laughing. Becca kissed me until my toes started to tingle (or maybe that was from the cold?). Her mouth was hot, her tongue a frenzy of motion. I was almost forgetting where we were when she jumped up and trotted over to stand beneath one of the trees, a twenty-foot pine with sporadic branches for the first six feet from the ground. She curled her mitten-clad fingers at me,

beckoning. I struggled to my feet and followed.

"I didn't want you to get too wet there in the snow," she said. "Turn around." I did, and she brushed me off, her hands particularly clingy around my upper thighs. The kissing and rolling around hadn't made just my toes tingly, I had to admit. The moist warmth growing in my cunt was a nice contrast to the clear, cold day.

Becca finished her ministrations and turned me, walking me a step backwards until I was pressed against the tree. "Put your hands up," she said, "and grab hold of that branch above your head." I did, wondering what she had in mind. I felt like a sacrificial virgin. She slipped off her mittens and shoved them in her pocket, then unzipped my down vest.

"Hey!" I protested, reaching down to stop her. She grabbed my hands and pulled them above my head.

"Hold on to the branch," she instructed. "Unless you want me to use that scarf to tie your wrists up there?"

A dull ache spread out from my pussy. We'd talked about trying some light bondage, but hadn't gotten around to it yet, although it intrigued us both. Now, though, wasn't the time I wanted to try. Suddenly I just wanted to do what Becca told me to do.

"Okay, I promise to be good," I whispered. "I'm at your mercy."

Her grin was appreciative and wicked, all at the same time. I knew I was in for it, and boy was I looking forward to it.

"You're crazy, you know that?" I said as she parted my vest and slid her hands beneath my sweater. "What if someone sees us?"

"Nobody ever comes up here," she said. Her hands moved higher, finding my nipples, already budded hard beneath my own silk turtleneck. My body throbbed. "It's private land."

I didn't make another protest, but she added, "I'm just trying to help you live in the moment."

To be honest, I couldn't think much past the maddening feel of her fingers massaging my breasts through the slippery soft silk. She pushed my sweater up and suckled one of my nipples through the silk. When she pulled away, my nips contracted harder, reacting to the cold air and the moisture.

I needed to feel her lips on my flesh, with no fabric barrier between.

Becca knelt before me and tugged the undershirt out of my waistband. My stomach contracted against the rush of air. She nuzzled her cold nose into my

belly, and I yelped softly. She laughed, her breath warm against my skin. Goosebumps skittered across my flesh, but I didn't want her to stop.

When she stood to reach my nipples, I saw a flash of white in her hand, and before I could register what it was, she pressed the snow to my breast.

I howled in surprise and nearly let go of the branch. My nipple was so hard it hurt, but a moment later her mouth was on it, hot and sucking hard, and my knees would have buckled if I hadn't been holding on. She repeated the process on my other breast, and again on the first, back and forth, back and forth, until heat and cold became a single burning sensation. I was so close to coming, just from the breast play. My cunt was shivering with tiny spasms that weren't quite orgasms, and the moans coming from my mouth were noises I didn't think I'd ever made before.

"Please…"

Becca pulled my jeans and underwear down below my knees, as far as they'd go before getting caught by the tops of my boots. Frigid air blew across my thighs, but my cunt was still scalding.

"Close your eyes." Becca's voice was thick with lust.

I did what she told me to do. I felt her hand stray between my legs, and using the branch for support, I bent my knees to give her access, since I could spreadn't my entangled feet.

She found that I was wet to my inner thighs. Her caress was too light for me to come, but it held the promise of enduring pleasure. Becca's petiteness extended to her hands, and sometimes, if I was wet enough, she could reach completely inside of me.

I was wet enough now—I was sure of it. But she toyed with my folds, which I imagined were steaming as they came into contact with the winter air.

"Open your mouth."

I expected Becca to bring her hand to my mouth, to slide in her fingers that would be sweet and pungent and slick with my juices.

Instead something hard passed my lips. Hard and cold and long and thick and shaped like…

My eyes flew open. Becca's green eyes had gone nearly black with excitement, but she managed a tremor of a smile as she slid the icicle back out of my mouth. Her other hand was still between my legs, driving most coherent thought from my head.

Still, I knew what she was going to do with that natural, frozen dildo.

My mittened hands clung to the branch above me as she drove it inside of me. It wasn't cold, but burning hot, and oh, so slick, like the glass dildo I'd once owned. I screamed as I clenched and came, bucking my hips as the world whirled in a kaleidoscope of cardinal red and snow white.

I melted.

I slid down the trunk, not caring if my down vest tore against the rough bark. Becca dropped to her knees next to me, helped me raise my hips so she could slide my jeans back up so I wasn't sitting bare-assed in the snow.

"You're so freakin' hot," she said, her voice hoarse, "that you completely melted the icicle. Damn."

I couldn't answer. Couldn't speak. My body started to shake from the sobs I couldn't keep down. I wasn't making any noise, but the tears were on my cheeks, and Becca began kissing them off.

"What's wrong, love?" she asked, her voice now tinged with concern.

I managed to form words. "I let go of the branch."

I know she didn't mean to laugh. For what it's worth, I did know she wasn't laughing at me, and I took no offense. Instead I buried my face into her

shoulder, glad she wasn't angry.

"Sweetness, what matters is that you trusted me for that long," she said, rocking me back and forth. "You held on a lot longer than I expected. And there was never, ever any penalty for letting go."

Christmas Eve. I sat on the floor, my back against the sofa, my head tilted back to watch the psychedelic play of blinking colored lights against the ceiling.

Yes, I was still with Becca, about to celebrate with her one of the biggest, most emotional holidays of the year. Fact was, something had snapped in me, that day in the woods. Or, more rightly put, something had thawed.

I still missed Lindy, and loved her dearly. But she was gone. I had to move on.

Becca had showed me how to trust again.

Before we'd left the clearing that day, Becca had pulled a long, bright red nylon cord out of her pack and wrapped it around the trunk of the tree where we'd just made love. I asked her what she was doing.

"This will tell my dad what tree we want," she said. "He knows where this clearing is; we used to picnic here when I was a kid."

I stared at her, wondering if the lust had fried her

brain, too. "But it's twenty feet tall."

Becca led me to the center of the clearing, near the indentations where we'd lain, and put her arms around me. "Look up," she said, and I did. "The top of the tree is perfect," she said.

And she was right: the top of the tree, especially about seven feet or so, was a flawless conical shape, like a storybook Christmas tree.

"We never take the trees from down below," she said. "We always pick a taller one, and then Dad uses the rest of it for firewood." She grinned mischievously, wiggling her body against mine. "Besides, don't you want that reminder sitting in our living room every day for the rest of the month? I think it'll be…quite inspirational."

She'd been right about that, too. Let's just say we'd been creating our own erotic Twelve Days of Christmas.

Now Becca came into the living room, bearing a tray with milk and sugar cookies. She was wearing a Santa hat, with a button pinned to it that displayed a piece of greenery and the words "Mistletoe: Kiss Below."

So I did. For a good long time.

Contributors

Shari J. Berman is a writer, translator, educator, and entrepreneur. Her first novel, *Kona Dreams*, was released in English in 2002 by Justice House Publishing, Inc., and her serial, *The Selena Stories*, is online at the publisher's site http://www.justice-house.com The German editions of her first two novels are published by el!es. Other short fiction appears in anthologies from Alyson, Arsenal Pulp, el!es and Robinson Publishing in the U.S., Canada, Germany and the U.K., including the title story for *Wilma Loves Betty and other Hilarious Gay and Lesbian Parodies.*

M. Christian is the author of the collection of lesbian erotica, *Speaking Parts* (Alyson) and is editor of numerous anthologies, including *Best S/M Erotica* (Black Books), *The Burning Pen* (Alyson), *Love Under Foot* (with Greg Wharton, Haworth Press), and *Leather, Lace, and Lust* (with Sage Vivant, Venus Book Club).

Andrea Dale is the pseudonym for a published fantasy author who also dabbles in erotica. Her fantasy stories have

appeared in *Sword & Sorceress* #16, *Marion Zimmer Bradley's Fantasy Magazine* #25, and *The Witching Hour* anthology (Silver Lake Publishing) among others. Her erotica can be found in *Sacred Exchange* (Blue Moon Books) and *TouchWords* Vol. II. Under the name Sophie Mouette she has also published erotica co-written with one of her lovers. She lives in southern California.

Kate Dominic loves celebrating unique Christmas traditions almost as much as she loves writing slightly heretical Christmas stories. She is the author of *Any 2 People Kissing* (Down There Press), in which she slides up and down the Kinsey scale in female and male voices. Her erotic stories have been published in various volumes of *Best Lesbian Erotica, Best Women's Erotica, Wicked Words,* and *Herotica,* as well as *Tough Girls, Strange Bedfellows,* and many other anthologies and magazines under a variety of pennames. Although Kate grew up in the Midwest, she now lives in Southern California. In the highly unlikely event that her mother reads this book, she reminds Mom that fiction is not (necessarily) autobiographical.

Sacchi Green spends her time in western Massachusetts, with occasional forays into the real world. She's published fiction in five volumes of *Best Lesbian Erotica,* three volumes of *Best Women's Erotica, Best Transgender Erotica, The Mammoth Book of New Erotica, On Our Backs, Penthouse,* and a knee-high stack of other anthologies with very inspirational covers.

Karin Kallmaker is best known for more than a dozen lesbian romance novels, from *In Every Port* to *Maybe Next Time.* In addition, she has a half-dozen science fiction, fantasy and supernat-

ural lesbian novels under the pen name Laura Adams, including *Seeds of Fire*. The work included in this anthology is part of her "Beyond Mango Erotica" series. Karin and her partner will celebrate their twenty-seventh anniversary in 2004, and are Mom and Moogie to two children.

Clio Knight is an Australian writer of erotica and romance. Her previous work can be found in *Best Women's Erotica 2003*, *Mythic Fantasies, Erotic Epistle, Seska for Lovers, and Amoret Online*. In real life she is studying for her PhD in Classics, specialising in Imperial women of Ancient Rome. She can be contacted at clioknight@tansyrr.com

Anya Levin is the penname of a rather unknown writer who finds exploring a fictional character's relationships easier than trying to manage her own real-life relationship. Difficulty aside, she and her partner have been together for six years. Anya lives with said partner, three cats and a strangely mottled rabbit in the suburbs of Philadelphia, Pennsylvania.

Lori Selke is the editor of *Tough Girls: Down and Dirty Dyke Erotica* (Black Books) and the zine *Problem Child*, and the music columnist for *Girlfriends Magazine*. Her fiction has appeared in *Best Lesbian Erotica 2002*, *Best S/M Erotica*, and *Best Bisexual Erotica 1 and 2*. Her favorite holiday movie is *The Nightmare Before Christmas*. She once tried not lighting candles at a Yule ritual to see if the sun would fail to come back.

Susan St. Aubin has been publishing erotica for almost 20 years, most recently in *Best American Erotica 2003, Ripe Fruit: Erotica for*

Well Seasoned Lovers, Best Women's Erotica 2002, and *Best Lesbian Erotica 2001.* She'll have a new story in *Best Women's Erotica 2004.*

Sage Vivant is the proprietress of Custom Erotica Source (http://www.customeroticasource.com), the home of tailor-made erotic fiction for individual clients since 1998. She has been a guest on numerous television and radio shows nationwide. Her work has appeared in *Best Women's Erotica 2004, Mammoth Book of Best New Erotica 2003, Naughty Stories from A to Z (II), Best Bondage Erotica, Naughty Fairy Tales, Five Minute Erotica, Love Under Foot, Down and Dirty, Villains and Vixens, Short and Sweet,* and *Juicy Erotica.* She is the editor of *Swing: Third Party Sex,* and co-editor with M. Christian of *Leather, Lace, and Lust* and *Binary: Bisexual Erotica.*

If Zonna's life were half as exciting as some of her stories, she wouldn't have time to write! She's been published in numerous anthologies, including *Best Women's Erotica 2002, Early Embraces, Hot & Bothered II and III, Shameless: Intimate Erotica, Skin Deep,* and *Dykes with Baggage,* among others.

If you enjoyed *Dyke The Halls* look for some of our
other delicious fiction, including:

Stocking Stuffers: Homoerotic Christmas Tales, edited by David
Laurents, $12.00, ISBN 1-885865-42-2

Best Transgender Erotica, edited by Hanne Blank and Raven
Kaldera, $16.00, ISBN 1-885865-40-6

Stars Inside Her: Lesbian Erotic Fantasy, edited by Cecilia Tan,
$14.95, ISBN 1-885865-19-8

And our series of gay and lesbian-themed science fiction,
The Ultra Violet Library:

The Drag Queen of Elfland, by Lawrence Schimel, $10.95, ISBN
1-885865-17-1

Things Invisible to See: Tales of Gay and Lesbian Magic Realism,
edited by Lawrence Schimel, $12.95, ISBN 1-885865-22-8

Through a Brazen Mirror, by Delia Sherman, $14.95, ISBN 1-
885865-24-4

Available in fine bookstores everywhere or from us by mail. Visit
www.circlet.com for details or send check or money order in
US dollars (include $4 shipping for the first book, $1 for each
additional book, within US/Canada only) to:

Circlet Press, Inc.
1770 Mass. Ave. #278
Cambridge, MA 02140